ROCHESTER OF
The Premo Camera

THE PREMO CAMERA
Rochester Optical Co.
1898

Cameras, Lenses, Accessories

Illustrated Catalog and Historical Introduction

AMERICAN HISTORICAL CATALOG COLLECTION

THE PYNE PRESS
Princeton

Library of Congress Catalog Card Number 78–146207

ISBN 0–87861–005–7

Printed in the United States of America

Note to the Reader. The 1898 Premo catalog was issued originally in a horizontal format. This has been retained, but for the purpose of inclusion in the American Historical Catalog Collection, the pages have been turned 90 degrees, and have been slightly enlarged. Notations in the text state that the illustrations facing pages 13, 18, 26, 72, 77 and 93 have been reduced from the original art; these, also, have been enlarged in the present edition.

THE PREMO CATALOGUE FOR 1898

PREMOS PRODUCE PERFECT PICTURES

1883–1898

With this issue of our Annual Catalogue we begin the sixteenth year as manufacturers of Photographic Cameras.

At the opening of another season we desire to express in large measure appreciation for the generous support accorded our efforts in the past, and to assure our friends the present high standard of quality that has gained for the Premo Camera a world-wide reputation, will be fully maintained.

For a decade and a half the Rochester Optical Co., under the management of Mr. W. F. Carlton, has been engaged exclusively in the manufacture of photographic apparatus, and during this entire period it has been the policy of the house to carefully study the needs and cater to the requirements of amateur photographers.

As the result of our efforts we present what is recognized as the most exquisite series of hand cameras ever devised—the Premo in its twenty-five different styles. These instruments have achieved a national reputation. They embody all that skill, money and brains can devise. Their perfect construction, ease of manipulation, grace, beauty and superb finish, have placed them in the front rank, and they are to-day the favorite Cameras with amateur and professional photographers.

3

Surely a line of apparatus evolved under such conditions cannot fail to win favor and command a leading position. Is it any wonder that "PREMOS Produce Perfect Pictures?"

How often we hear the remark, "Just as good as a PREMO". The popularity enjoyed by the PREMO ever since its introduction in 1893 has led other manufacturers to copy, so far as is possible, its general style and design; but, after all, imitation is but flattery. We court comparison—believing that a careful examination into details of construction, to say nothing of other advantageous features alone possessed by our goods, will fully prove all claims, and demonstrate that PREMOS are built for making perfect pictures.

Our assortment of Cameras for 1898 is complete, embracing outfits of such moderate cost that the demands of even the most modest amateur can be fully met, while for those desiring instruments of a higher type, we have a large number of styles from which the most advanced worker cannot fail to make a satisfactory selection.

In buying a PREMO—no matter what the cost may be—the purchaser rests secure in the fact that it is fully guaranteed by its manufacturers, who have a reputation of fifteen years' standing to maintain.

There is an old adage to the effect that in order to obtain the best results a workman must have proper tools. Moral: "PREMOS PRODUCE PERFECT PICTURES."

4

AMATEUR PHOTOGRAPHY

Photography is growing more and more in favor the world over. It affords greater attractions than all the arts heretofore introduced in popular form, for while it answers fully the requirements of mechanical taste, it offers constant opportunities for the exercise of other intellectual qualities.

THE LOVE OF PICTURES and the desire to produce them in some form are prominent characteristics in the human mind. Formerly lovers of the beautiful tried to garner up the choice bits of nature with the aid of brush or pencil; but now how easy to save not only outline but detail as well with the camera.

PHOTOGRAPHY IS INSTRUCTIVE enjoyable, and very fascinating. It educates the eye, teaches one to observe more closely objects in the every-day walks of life, and is in every way elevating to the human mind. So simple and certain are its methods that an intelligent child can make admirable pictures; yet so mysterious are the causes which produce the exquisite results that scientists disagree and are in doubt as to their precise nature.

5

THE VALUE OF is now recognized by leading manufacturers, architects, engi-
PHOTOGRAPHY neers, artists, physicians, surgeons—in fact by men and women
in nearly every walk of life.

FOR THE photography affords the means of securing a pictorial diary of the
BICYCLIST many scenes and incidents constantly passing in panoramic view,
as he pedals mile after mile on his steed of steel.

In the following pages will be found apparatus designed especially for the use
of Wheelmen. So compact and portable are these new cameras, that they can be
attached to a bicycle the same as a tool bag, without causing any inconvenience.

TO THE photography affords a never ending source of enjoyment. To record
TOURIST with accuracy the events and scenes of his tour is an enjoyment at
the time, and a greater one when he sees the finished photograph which is always
a valuable memento of a pleasant holiday.

BUSINESS own a Premo for the pleasure they derive from it, and as a source
MEN of relaxation from the cares of the office. The most enthusiastic
amateurs are among those who stand high in the business world.

MANUFACTURERS recognize the value of photography as a means of accurately
representing their products. A photograph of a machine or other wares gives a
truthful and readily comprehended idea of their value; the minutest detail, which
neither pencil, brush nor graver can portray accurately, is faithfully represented.

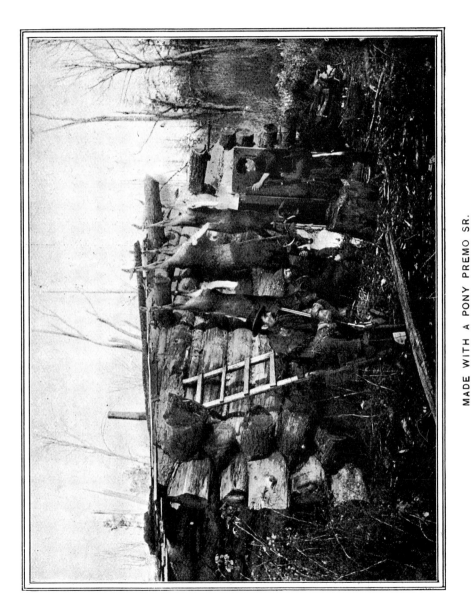

MADE WITH A PONY PREMO SR.

INSURANCE MEN use photography to a great extent to take views of risks for the home office, as a photograph conveys more definite knowledge than a sketch or diagram, and is much easier obtained.

PHYSICIANS AND SURGEONS with the aid of a Premo Camera are enabled to note and pre-serve for reference, photographs of the many interesting cases constantly being brought under their care. The exposure is all that is necessary to be made in the sick room, and requires but a few moments time.

SPORTSMEN will find the Premo Camera a valuable companion. Pictures of camp-life will prove intensely interesting to the friends at home, who are thus enabled to catch a glimpse of life in the woods. Then too they are not "fish stories" when you can show a photograph of the "catch."

ARTISTS now use the Premo to replace the slow process of sketching. Where it would require hours to sketch a view, it will take but a few seconds to make an exposure with the camera, and the minutest detail is preserved.

ARCHITECTS find the Premo invaluable, as it enables them quickly and at a small cost to secure a record of their executed work to show a client when necessary. The power of a photograph to seize the minutest detail, gives it a value far beyond the most careful free-hand sketch. Not only is there a charm to the architect in photographing his own work, but the rapidity with which he can secure views makes photography of great value to him.

ENGINEERS find the Premo a valuable aid, as in making reports to their chiefs of the progress of work on a contract, they find that a photograph will give a more definite idea than the longest written report. Photographs containing data as to the number of men employed, state of weather, etc., will convey an idea how much work a certain number of men will do in a given time.

SELECTING A CAMERA.

A Camera that will afford the amateur the most pleasure, and prove of the highest service, must possess such features as will adapt it for "all around work," as the field now covered by the ambitious photographer is a wide one, and constantly growing.

A good Lens is a most important part of the outfit, as well as a durable Time and Instantaneous Shutter, free from jar and vibration. Compactness is a desirable point, provided strength and rigidity are not sacrificed to secure it. Another feature, and one of great importance, is the ease with which the Camera may be manipulated. It should be simply constructed and free from complicated parts. An instrument combining in the highest degree these important factors will be found to best meet the demands of the amateur photographer.

PREMO CAMERAS

Combine these features, with many others, in an eminent degree. The Premo, when first introduced in 1893, was pronounced the most practical Hand Camera in the market, and it has held this enviable position each succeeding year. The models for 1898 eclipse all former efforts, and still render the Premo unapproachable.

CAN I SUCCEED? We are frequently asked the question, "Can I succeed in making good photographs, even though I have had no experience?" Our answer is "Yes." We wish it were more generally known how easy it is to make the most beautiful photographs. Provided the amateur is supplied with apparatus of approved quality, we have no hesitancy in emphasizing the statement that anyone of average intelligence and ability can readily produce pictures of the most satisfactory character without previous experience.

FULL INSTRUCTIONS for making photographs will be found in our guide book, *The Amateur Photographer*, furnished with each Premo Camera. This book is conceded to be the simplest, most concise and practical work of the kind ever published, and is a complete guide for the beginner in photography.

OUR GENERAL CATALOGUE. In addition to Hand Cameras, we also manufacture a complete line of regular View or Tripod Cameras and accessories, fully described in our General Catalogue. We shall be pleased to mail a copy to those interested.

TESTING Every Premo is carefully tested and critically inspected before leaving the factory, thus insuring perfect adjustment in every part.

SELECTING A PREMO. When deciding as to which particular Camera will answer your purpose best, we suggest that you look carefully over the various styles and note the description of each. The large assortment and wide range in price affords opportunity for satisfying the demands of the novice, advanced amateur or photographic expert.

SAMPLE PHOTOGRAPHS. Upon receipt of 5 cents in stamps we will forward a specimen photograph made with any desired style of 4 x 5 Premo, or for 8 cents we will send a sample made with the 5 x 7 size.

IF YOU ARE IN DOUBT regarding any point—write us. We shall be glad to answer any questions you may ask, and furnish such information as will aid you in making a judicious selection of an outfit.

MADE WITH 5 x 7 PREMO A. (REDUCED.)

GILL-ENG-CO·N·Y·

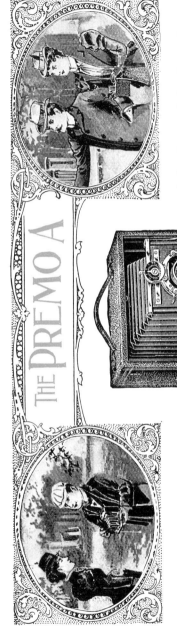

The Premo A

Premo A is the or- iginal model, first intro- duced in 1893, and which met with such a flattering reception by the best amateur and professional photographers at home and abroad. We have added many new and val- uable features, and also materially reduced the size and weight The 4 x 5 measures, when closed, 5¾ x 6⅞ x 4⅝ inches, including space for three plate holders or roll holder, and weighs only a trifle over two pounds. Premo A is fitted with Rising and Falling Front, also a fine Rack and Pinion movement for focusing, and Swing Back, operat- ing from the center.

The Lens is the Victor Rapid Rectilinear, adapted for general work, and made especially for use with the Premo. This lens may be removed from the shutter and the Victor Wide Angle substituted, when desired, as the cells of both are interchangeable.

The new Victor Shutter, having both finger and pneumatic release, and fitted with Iris Diaphragm, is one of the features of the outfit. The Lens and Shutter are more fully described on pages 77 and 80. The View Finder is attached to the bed and is reversible. Premo A is provided with two tripod plates, and has a panel at the back for focusing. The ground glass screen is spring actuated. Glass Plates, Cut and Roll Films may all be used. The Plate Holder is the Perfection Jr, with rubber slides. The Roll Holder is of latest design, arranged for Cartridge or Light Proof Film, and can, therefore, be loaded in daylight.

The price includes Camera, Lens, Shutter and one double Plate Holder.

PRICES:

	3¼ x 4¼	4 x 5	5 x 7	6½ x 8½
Premo A,	$25.00	$25.00	$33.00	$42.00
Wide Angle Lens, extra,		10.00	12.00	15.00
Extra Plate Holders,	1.00	1.00	1.25	1.60
Cut Film Holder,	1.35	1.35	1.60	1.85
Cartridge Roll Holder, Empty,	5.00	5.00	6.50	12.00*
Light Proof Roll of Film,	12 Exp., .75	12 Exp., .90	12 Exp., 1.60	24 Exp., 4.00 48 Exp., 8.00
Leather Covered Case,	2.50	2.50	3.00	3.50
Sole Leather Case,	3.50	3.50	4.00	4.50

*Not made for Cartridge Film.

STEAMER "EXCELSIOR" LEAVING SAN FRANCISCO FOR THE KLONDIKE, JULY 28, 1897.

MADE WITH 4 x 5 PREMO SR.

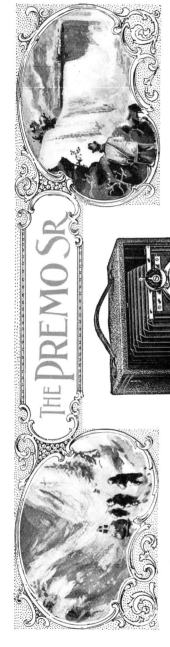

THE PREMO SR.

THE PREMO SR. represents the highest type of the Hand Camera, and w i l l, without question, find favor among those of our friends desiring a strictly high grade outfit, possessing the very latest improvements. We have spared no pains to make the Premo Sr. the best camera in existence in every detail. The success of our efforts in this direction can only be judged by a careful examination of the instrument itself, as it is impossible to otherwise obtain a conception of its "completeness." The substantial construction, extreme compactness and portability, beauty of design, ease of manipulation, and general fine finish, are a few of its many prominent features.

The Premo Sr. is made from selected mahogany, covered with fine black leather. The appearance of the camera when open, is extremely handsome, the finely polished mahogany bed, and lacquered metal work being in perfect contrast with the black leather covering.

16

The Premo Sr. has Double Swing Back, Double Sliding Front and Rack and Pinion for focusing, the working parts of which are entirely within the case, and when closed is merely a neat leather covered box.

Both the horizontal and vertical swings are at the center of the plate, and may be quickly adjusted by means of a spring lever, working in a series of notches in a brass plate at the side.

The Premo Sr. is fitted with two tripod plates, and has a panel at the back for focusing on the ground glass when desired. A reversible View Finder is attached to the bed for upright or horizontal pictures.

We make the bed in two sections, hinged together, when desired for use with extremely Wide Angle Lenses; ordinary Wide Angle Lenses do not require it.

The Lens is the Victor Rapid Rectilinear, possessing great power, and constructed especially for Hand Camera work. It may be removed from the shutter and the Victor Wide Angle substituted, as the cells of both lenses are interchangeable.

The new Victor Shutter, with Iris Diaphragm, is furnished with the Premo Sr. and forms a prominent part of the outfit. It works between the lenses without noise or jar, and may be adjusted for time exposures as well as for rapid instantaneous work. A description of both lens and shutter is given on pages 77 and 80.

The ground glass is spring actuated, and recedes to allow insertion of holder.

The Holder is our Perfection, Jr, with rubber slides, recognized as being the best in the market. Glass Plates, Cut and Roll Films may all be used, the holders being interchangeable.

The Roll Holder is the latest pattern, arranged for Light Proof or Cartridge Rolls of film, and it can, therefore, be loaded in daylight.

The size of the 4 x 5 Premo Sr. when closed is only $5\frac{5}{8}$ x $4\frac{5}{8}$ x 7 inches, including space for three holders, or Roll Holder, and it weighs but $2\frac{1}{4}$ pounds.

The price includes the Camera, Lens, Shutter, and one Double Plate Holder.

PRICES :

	$3\frac{1}{4}$ x $4\frac{1}{4}$	4 x 5	5 x 7	$6\frac{1}{2}$ x $8\frac{1}{2}$	8 x 10
Premo Sr.,	$30.00	$30.00	$40.00	$50.00	$60.00
Wide Angle Lens, extra,		10.00	12.00	15.00	18.00
Hinged Bed, extra,		3.00	3.00	3.50	4.00
Extra Plate Holders,	1.00	1.00	1.25	1.60	2.00
Cut Film Holders,	1.35	1.35	1.60	1.85	2.30
Cartridge Roll Holder, empty,	5.00	5.00	6.50	12.00*	
Light Proof Roll of Film,	12 Exp., .75	12 Exp., .90	12 Exp., 1.60	24 Exp., 4.00 48 Exp., 8.00	
Leather Covered Case,	2.50	2.50	3.00	3.50	4.00
Sole Leather Case,	3.50	3.50	4.00	4.50	5.00

*Not made for Cartridge Film.

MADE WITH 5x7 REVERSIBLE BACK PREMO SR. (REDUCED.)

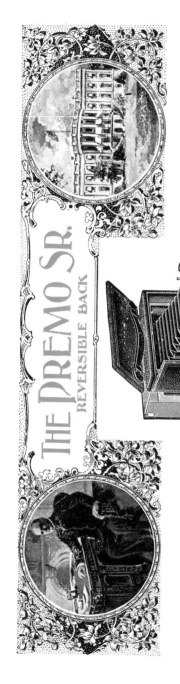

THE PREMO SR.
REVERSIBLE BACK

The REVERSIBLE design, presented for the first time this season, will find favor among those who believe in using a tripod more or less in connection with Hand Cameras.

It is practically a counterpart of the regular PREMO SR., which has proved so popular, but having, as its name indicates, the back arranged to reverse for either upright or horizontal pictures. With this adjustment the image may be examined on the ground glass screen in both positions without in any way disturbing the body of the Camera.

BACK PREMO SR. is a new

This will be found convenient in many cases, as the operator is often undecided whether a horizontal or vertical position of the plate is the most artistic. Aside from this feature, however, the description of Premo Sr. given on pages 16 to 18, will apply as well to the Reversible Back Premo Sr.

This Camera contains every adjustment demanded by the most advanced workers, and will, we believe, prove equally as popular among both amateur and professional photographers as the regular Premo Sr.

The Reversible Back PREMO has Double Swing, Double Sliding Front, also Rack and Pinion for focusing, the working parts of which are entirely within the case. The Camera when closed is merely a neat leather covered box.

Both the horizontal and vertical swings are at the center of the plate, and may be quickly adjusted by means of a spring lever, working in a series of notches in a brass plate at the side.

We make the bed in two sections, hinged together, when desired for use with Wide Angle Lenses.

The Lens is the Victor Rapid Rectilinear, possessing great power, and constructed especially for Hand Camera work. It may be removed from the shutter, and the Victor Wide Angle substituted, as the cells of both lenses are interchangeable.

The new Victor Shutter is furnished with the Reversible Back Premo Sr., and forms a prominent part of the outfit. It works between the lenses without noise or jar, and may be adjusted for time exposures as well as for rapid instantaneous work. A description of both lens and shutter is given on pages 77 and 80.

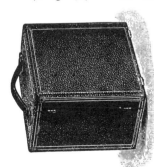

The ground glass is spring actuated, and recedes to allow insertion of holder.

The Perfection Jr. Holder, with rubber slides, is furnished. Glass Plates, Cut and Roll Films, may all be used, the holders being interchangeable.

The Roll Holder is the latest pattern arranged for Light Proof or Cartridge Rolls of Film, and it can, therefore, be loaded in daylight.

The size of the 4 x 5 Reversible Back Premo Sr. when closed is only 5 x 7 $\frac{1}{8}$ x 7 $\frac{1}{8}$ inches, including space for three holders, and it weighs but 2$\frac{3}{4}$ pounds.

The price includes Camera, Lens, Shutter, and one Double Plate Holder.

PRICES:

	4 x 5	5 x 7	6½ x 8½	8 x 10
Reversible Back Premo Sr.,	$35.00	$45.00	$55.00	$65.00
Wide Angle Lens, extra,	10.00	12.00	15.00	18.00
Hinged Bed, extra,	3.00	3.00	3.50	4.00
Extra Plate Holders,	1.00	1.25	1.60	2.00
Cut Film Holders,	1.35	1.60	1.85	2.30
Cartridge Roll Holder, empty,	5.00	6.50	12.00*	
Light Proof Roll of Film, 12 Exposures,	.90	12 Exp., 1.60	24 Exp., 4.00 48 Exp., 8.00	
Leather Covered Case,	2.50	3.00	3.50	4.00
Sole Leather Case,	3.50	4.00	4.50	5.00

*Not made for Cartridge Film.

22

MADE WITH 4 x 5 LONG FOCUS PREMO

THE LONG FOCUS PREMO

THE LONG though a comparison of Hand Camera, found great favor among a very large number of both amateur and professional photographers. As its name indicates, this style Premo possesses an extra long bellows, adapting it for the use of very long focus lenses, as well as those usually furnished.

FOCUS PREMO, atively new form is a style that has

Though combining the features of both hand and tripod cameras, the Long Focus Premo is compact and light in weight, yet every adjustment may be quickly made.

When not fully extended the Long Focus Premo is similar in appearance to the Premo Sr., as a glance at the illustration on the next page will show, and it may be used in the same manner, either for hand or tripod work.

Though but a trifle larger than the Senior, the Long Focus Premo has nearly double the focal capacity.

24

The extra length of draw is obtained by the addition of a folding back. By simply touching a spring at the top, the back of the camera will drop, forming a bed, upon which the rear portion of the camera carrying the ground-glass screen will slide. A glance at the illustration on page 24 will convey the idea.

The Long Focus Premo may be used for copying, enlarging and all other purposes requiring an extended length of bellows.

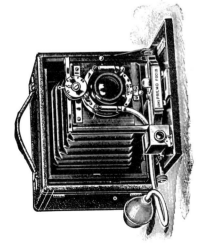

The lens is the Victor Rapid Rectilinear, the same as furnished with the Premo Sr., and will be found described on page 77. Being symmetrical the front combination may be removed, and the rear lens used alone when desired, which approximately doubles the length of focus. For distant views this is valuable as the objects in the view are larger in the picture.

The Long Focus Premo has Double Swing Back, Double Sliding Front, and a fine Rack and Pinion movement for focusing. A brilliant reversible View Finder is conveniently placed on the bed of the camera; two tripod plates are also fitted for both upright and horizontal pictures.

The Victor Shutter, with Iris Diaphragm, is fitted to the Long Focus Premo, a full description of which will be found on page 80.

The ground glass screen is spring actuated, and recedes to allow the insertion of the Plate Holder. The Perfection Jr. Holder is furnished with this camera.

Glass plates, Cut and Roll Films may be used as the holders are interchangeable.

As will be seen from the above description the Long Focus Premo covers a field never before reached by the Hand Camera, and its advantageous features have been quickly recognized and fully appreciated by both our amateur and professional friends.

FOCAL CAPACITY OR LENGTH OF BELLOWS.

4 x 5	5 x 7	6½ x 8½	8 x 10
15 inches.	19 inches.	22 inches.	28 inches.

The price includes Camera, Lens, Shutter, and one Double Plate Holder.

PRICES :

	4 x 5	5 x 7	6½ x 8½	8 x 10
Long Focus Premo,	$35.00	$45.00	$55.00	$65.00
Wide Angle Lens, extra,	10.00	12.00	15.00	18.00
Extra Plate Holders,	1.00	1.25	1.60	2.00
Cut Film Holder,	1.35	1.60	1.85	2.30
Cartridge Roll Holder, empty,	5.00	6.50	12.00*	
Light Proof Roll of Film, 12 Exposures, .90	12 Exp., 1.60	24 Exp., 4.00		
			48 Exp., 8.00	
Leather Covered Case,	2.50	3.00	3.50	4.00
Sole Leather Case,	3.50	4.00	4.50	5.00

*Not made for Cartridge Film.

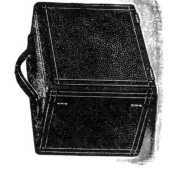

26

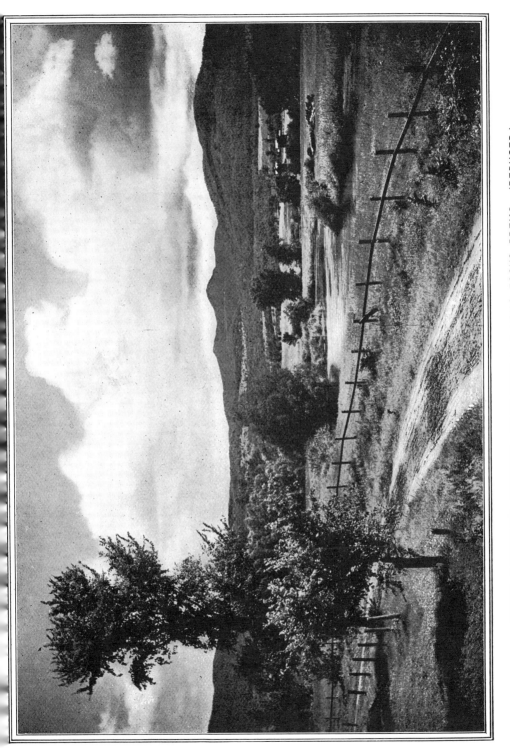

GREEN MOUNTAINS, VERMONT. MADE WITH 5 x 7 LONG FOCUS PREMO. (REDUCED.)

THE REVERSIBLE-BACK PREMO

THE REVERS- is the outgrowth of a constantly increasing demand, especially among the more advanced amateur photographers, as well as our professional friends, for a combined Hand and Tripod Camera—an instrument possessing the advantageous features of the former pattern, together with the many useful adjustments heretofore found only in the latter style.

In the Reversible Back Premo we have evolved a camera designed to cover a field so wide in range, as to be almost universal in its application. In general appearance the camera resembles the regular Long Focus Premo, though it possesses even a greater focal capacity, and as its name indicates, has a Reversible Back. This adjustment is especially desirable when the camera is used on a tripod, as the position of the plate may be instantly changed without moving the camera.

The Reversible Back Premo is provided with all modern improvements. It has Double Swing Back, both Rising and Sliding Front and a fine Rack and Pinion movement, permitting most delicate focusing.

The horizontal and vertical swings both oscillate at the center of the plate, which is optically correct.

For the use of long focus lenses — for copying, enlarging and all other purposes requiring an extended length of bellows, the Reversible Back Premo is particularly well adapted.

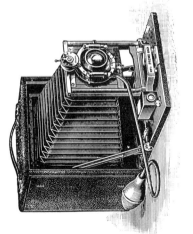

The Lens is the Victor Rapid Rectilinear, description of which is given on page 77. Being symmetrical, the front combination may be removed and the rear lens used alone, which practically doubles the focus. For mountain scenery and subjects at long range, this is often an advantage, as the objects in the view appear larger in the picture. The Rapid Rectilinear Lens may be removed from the shutter and a Victor Wide Angle substituted, as the cells are interchangeable.

The New Victor Shutter having a triplicate movement, with Iris Diaphragm, Pneumatic and Finger Release, is furnished with the Reversible Back Premo, and forms a prominent part of the outfit. It works between the lenses without noise or jar, and may be adjusted for time exposures as well as for rapid instantaneous work. A description of the shutter is given on page 80.

The View Finder is located in a convenient position on the bed. The ground glass screen is spring actuated, receding to permit the insertion of the plate holder. The holder is the Perfection Jr., with rubber slides.

Glass Plates, Cut and Roll Film may all be used. Combining the desirable features of both Hand and View Camera, the Reversible Back Premo will appeal to, and be fully appreciated by a very large class of both amateur and professional photographers.

FOCAL CAPACITY OR LENGTH OF BELLOWS

4 x 5	5 x 7	6½ x 8½	8 x 10
17½ inches.	23 inches.	29 inches.	33½ inches.

The price includes Camera, Lens, Shutter, and one Double Plate Holder.

PRICES:

	4 x 5	5 x 7	6½ x 8½	8 x 10
Reversible Back Premo,	$40.00	$50.00	$62.00	$72.00
Wide Angle Lens, extra,	10.00	12.00	15.00	18.00
Extra Plate Holders,	1.00	1.25	1.60	2.00
Cut Film Holder,	1.35	1.60	1.85	2.30
Cartridge Roll Holder, empty,	5.00	6.50	12.00*	
Light Proof Roll of Film, 12 Exp.,	.90 12 Exp., 1.60		24 Exp., 4.00	
			48 Exp., 8.00	
Leather Covered Case,	2.50	3.00	3.50	4.00
Sole Leather Case,	3.50	4.00	4.50	5.00

*Not made for Cartridge Film.

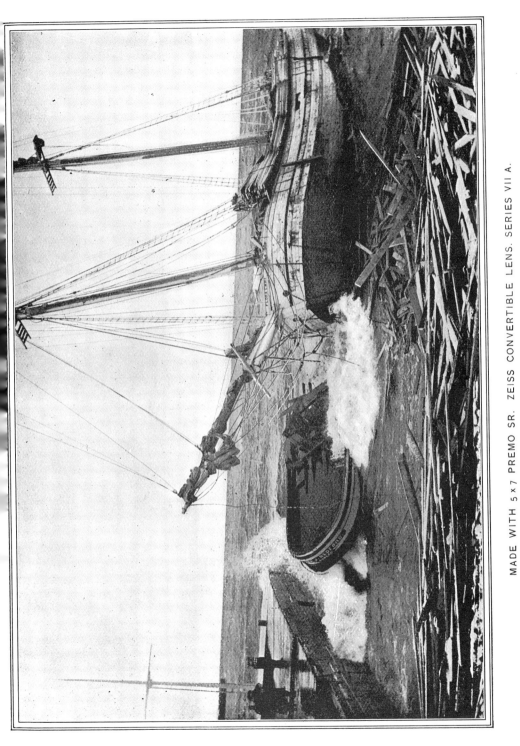

MADE WITH 5 x 7 PREMO SR. ZEISS CONVERTIBLE LENS. SERIES VII A.

THE PREMO SR. SPECIAL

THE PREMO SR. the very highest form ing a perfect model of "com- pleteness," from every stands for all that is SPECIAL represents of Hand Camera, be- photographic "com- point of view. It best in Camera, Lens and Shutter, as well as minor fittings, and no pains have been spared to make the Premo Sr. Special the highest possible grade of Photographic Apparatus.

The description of the Premo Sr., given on page 16, excepting Lens and Shutter, will apply equally well to the Premo Sr. Special.

This Camera is furnished with Zeiss Anastigmat Lens, Series IIA, fitted with the Bausch & Lomb Diaphragm Shutter.

The Lens yields an absolutely flat image, free from astigmatism, sharply de- fined to the extreme edges of the plate, and the speed is such as to particularly commend it for Hand Camera use. It includes an angle of about 75°.

In addition to flatness of field this Lens gives an unusual evenness of illumination, combined with great depth of focus, and is perfectly adapted for making large heads, figures, groups, etc., as well as for general instantaneous work.

The Diaphragm Shutter will meet every requirement of the amateur and professional photographer. It is constructed in the best possible manner, operates without concussion, and is practically noiseless in action. This Shutter works automatically from three seconds to the one hundredth part of a second, and by simply moving a small lever it may be set for time exposures of any desired duration.

With the wide reputation enjoyed by the Premo Sr. Camera, as well as the Zeiss Lens and Diaphragm Shutter, both at home and abroad, no argument is necessary to emphasize the strength of such a combination, photographically considered.

The price includes Camera, Zeiss Lens Series IIA, Diaphragm Shutter and one Double Plate Holder.

PRICES:

	4 x 5	5 x 7	6½ x 8½	8 x 10
Premo Sr. Special,	$67.00*	$84.00	$103.00	$120.00
Extra Plate Holders,	1.00	1.25	1.60	2.00
Cut Film Holder,	1.35	1.60	1.85	2.30
Cartridge Roll Holder, empty,	5.00	6.50	12.00†	
Light Proof Roll of Film,	12 Exp., .90	12 Exp., 1.60	24 Exp., 4.00	
			48 Exp., 8.00	
Leather Covered Case,	2.50	3.00	3.50	4.00
Sole Leather Case,	3.50	4.00	4.50	5.00

*Fitted with the No. 2 Lens.
†Not made for Cartridge Film.

33

MADE WITH GOERZ DOUBLE ANASTIGMAT LENS, SERIES III.

THE LONG FOCUS PREMO SPECIAL

The LONG SPECIAL represents a combination of Shutter that can be desired for either sional use. It contains all the good features embodied in the Premo Sr. Special, but covers even a wider range of work, owing to the extra length of bellows and Symmetrical Anastigmat Lens.

Focus PREMO sents the strongest Camera, Lens, and possibly be de-amateur or professional use. It contains all the good features embodied in the Premo Sr. Special, but covers even a wider range of work, owing to the extra length of bellows and Symmetrical Anastigmat Lens.

In constructing this Camera no expense has been spared to make it complete in all details. It is manufactured of the finest mahogany, handsomely polished and covered outside with heavy black grained leather. Every adjustment, such as Rising and Sliding Front, Double Swing Back, Rack and Pinion Movement, Drop Bed, for Wide Angle Lenses, Spring Actuated Ground Glass Screen, etc., is fitted, making it a perfect instrument for both Hand and Tripod work.

When using a Wide Angle Lens the brass side arm at either side is unlocked, permitting the entire bed to drop entirely out of range. The focus is then adjusted at the rear.

The description of the Long Focus and Reversible Back Premos given on pages 24 and 28, excepting Lens and Shutter, will apply with equal force to the Long Focus Special.

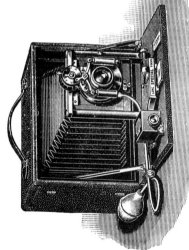

The Goerz Double Anastigmat Lens, Series III, furnished with this Camera, possesses great speed, depth of focus and remarkable covering power. The Astigmatism being completely corrected, the Lens, even when used with full aperture, will yield a perfectly sharp and brilliant image over the entire plate. For portraits, groups, architectural subjects, copying, and instantaneous work, it cannot be excelled.

The Goerz Lens is symmetrical, and when desired the front combination may be removed, the result being a single lens, approximately double the focus of the compound. For mountain scenery and subjects at long range, this is often an advantage, as objects in the view appear larger in the picture.

The combinations of the Series III Lenses are mounted in close proximity, with the result that there is no perceptible falling off in the illumination of the image toward the edges of the plate.

The Bausch & Lomb Diaphragm Shutter now so well and favorably known among the foremost amateur and professional photographers, is constructed in the best possible manner, being entirely in keeping with both Lens and Camera. It operates without concussion and is practically noiseless in action. The speed may be varied from three seconds to fractional parts of a second, and by simply moving a small lever it can be set for time exposures of any desired duration.

From the above description it will be seen the Long Focus and Reversible Back Premo Specials both represent outfits of the highest order, and cannot fail to meet the demands of the most advanced amateur and professional photographers.

The price includes Camera, Goerz Lens, Diaphragm Shutter and one Double Plate Holder.

PRICES :

		4 x 5	5 x 7	6½ x 8½	8 x 10
Long Focus Premo Special,	-	$85.00	$100.00	$132.00	$170.00
Reversible Back Premo Special,	-	90.00	105.00	139.00	177.00
Extra Plate Holders,	-	1.00	1.25	1.60	2.00
Cut Film Holder,	-	1.35	1.60	1.85	2.30
Cartridge Roll Holder, empty,	-	5.00	6.50	12.00*	
Light Proof Roll of Film, 12 Exposures, .90	12 Exp. 1.60	24 Exp. 4.00 48 Exp. 8.00			
Leather Covered Case,	-	2.50	3.00	3.50	4.00
Sole Leather Case,	-	3.50	4.00	4.50	5.00

*Not made for Cartridge Film.

37

The STEREOSCOPIC PREMO

S̲tereoscopic photographic photog-
raphy is one of the most
interesting branches of the art, and as the Hand
Camera is now designed especially for this class of
work, it will undoubtedly ain favor among a large
number of amateurs, who have heretofore never at-
tempted the production of Stereoscopic pictures.

We can furnish Premo A, Premo Sr., and Long Focus Premo in both 5 x 7 and
6½ x 8½ sizes, arranged for Stereo work, for which the front must be wider than
regular.

The Stereo Lenses are a matched pair of 4 x 5 Rapid Rectilinear Lenses, same
as used with 4 x 5 Premo A, and fitted with Bausch & Lomb Stereo Shutter, which
is constructed closely after the Diaphragm Shutter.

This Shutter is designed especially for use with Stereoscopic Lenses. The action
is so perfect that exactly the same amount of light is admitted through both lenses.

38

The regular lens and shutter and the stereo lenses are on different lens boards, so that the change from regular full sized views to stereo work requires but a moment's time.

The price includes the Victor Rapid Rectilinear Lens and Victor Shutter for full sized views, and the Stereo Lenses and Shutter, together with a division in the camera, and one Plate Holder. Glass plates, cut and roll films may all be used.

Wide Angle Lenses may be adjusted for full size views, same as with the Premo A or Premo Sr.

PRICES :

		5 x 7	6½ x 8½
Stereo Premo A,	- - - - -	$70.00	$80.00
Stereo Premo Sr.,	- - - -	75.00	85.00
Stereo Long Focus Premo,	- -	80.00	90.00
Wide Angle Lens, extra,	- -	12.00	15.00
Hinged Bed, extra,	- - -	3.00	3.50
Extra Premo Holders,	- -	1.25	1.60
Cut Film Holders,	- - -	1.60	1.85
Cartridge Roll Holder, empty,	- -	6.50	12.00*
Light Proof Roll of Film, 12 Exposures,		1.60	24 Exp. 4.00
			48 Exp. 8.00
Leather Covered Case,	- -	3.00	3.50
Sole Leather Case,	- - -	4.00	4.50

*Not made for Cartridge Film.

MADE WITH A 4 x 5 PREMO B.

THE PREMO B

PREMO B is a universal favorite among all camera at moderate cost, desiring a high grade and who do not care for the elaborate features possessed by the more expensive outfits. Its great popularity fully attests its merits, as it has proved one of the most popular styles of the entire series.

Premo B is similar in general design to Style A, being made of Mahogany, handsomely finished with metal work of polished and lacquered brass. The same care is exercised in its construction throughout, and for a high grade camera, possessing modern improvements, yet at a moderate price it stands second to none.

Our new Central Swing Back and Rising and Falling Front are fitted, thus adapting the camera for both hand and tripod work.

Premo B is furnished with the Victor Shutter, having Iris Diaphragm and pneumatic release, for description of which see page 80.

Either the R. O. Co.'s Single Achromatic or the Victor Rapid Rectilinear Lens is fitted, as may be preferred. The Rapid Rectilinear Lens is precisely the same as furnished with Premo A.

A reversible View Finder is fitted to the bed for both vertical and horizontal pictures; also two plates for attaching the camera to a tripod. The ground glass screen is spring actuated and recedes to allow the insertion of the plate holder.

The outside dimensions of 4 x 5 Premo B are only 4⅝ x 6⅞ x 5⅝ inches, including space for three plate holders or Roll Holder, and the weight a little over two pounds. It is handsomely covered with fine black leather, and has a leather handle for carrying. The Roll Holder is arranged for Cartridge Film and can be loaded in daylight. Glass Plates, Cut and Roll Films may be used.

Price includes Camera, Lens, Shutter and one Double Plate Holder.

PRICES :

	4 x 5	5 x 7
Premo B, with Achromatic Lens, -	$15.00	$23.00
With Victor Rapid Rectilinear Lens, -	20.00	30.00
Wide Angle Lens, extra, -	10.00	12.00
Extra Premo Plate Holders, - -	1.00	1.25
Cut Film Holders, - - -	1.35	1.60
Cartridge Roll Holder, empty, - -	5.00	6.50
Light Proof Roll of Film, 12 Exposures, .90		12 Exp., 1.60
Leather Covered Case, - -	2.50	3.00
Sole Leather Case, - -	3.50	4.00

The PREMO C

PREMO C will at large class of amateurs practical outfit at moderate cost.

This camera is very manship being of the neat in appearance, being shellacked inside and covered with fine black leather outside.

once find favor among a desiring a thoroughly erate cost.

carefully made, the workbest. It is exceedingly

It is provided with Central Swing Back and Sliding Front.

PREMO C is fitted with our well known Single Achromatic or Rapid Rectilinear Lens, with Rotating Diaphragm. It has our New Safety Time and Instantaneous Shutter, a neat and effective device for all classes of work. The Shutter is quickly set by a lever at the side, the leaves remaining stationary. The Shutter is spring acting, and recedes to allow the

The ground glass screen on Premo C is spring acting, and recedes to allow the insertion of the plate holder.

The View Finder is attached in a convenient position on the bed, and is reversible for both upright and horizontal pictures. Two tripod plates are fitted.

Premo C is very compact, the 4 x 5 measuring only 4⅝ x 5⅝ x 6⅞ inches, including space for three plate holders or roll holder. It weighs but a trifle over two pounds.

Either Glass Plates, Cut or Roll Films may be used. The Roll Holder is of the latest design for Cartridge or Light Proof Film. It can be loaded in daylight.

From the above description it will be seen that Premo C is fitted with the necessary adjustments for the large and varied character of work usually attempted by the ambitious amateur.

Price includes Camera, Lens, Shutter and one Double Plate Holder.

PRICES :

	4 x 5	5 x 7
Premo C, with Achromatic Lens, - -	$12.00	$20.00
With Rapid Rectilinear Lens, -	17.00	26.00
Extra Premo Plate Holders, - -	1.00	1.25
Cut Film Holders, - - -	1.35	1.60
Cartridge Roll Holder, empty, -	5.00	6.50
Light Proof Roll of Film, 12 Exposures, .90		12 Exp., 1.60
Leather Covered Case, - -	2.50	3.00
Sole Leather Case, - - -	3.50	4.00

44

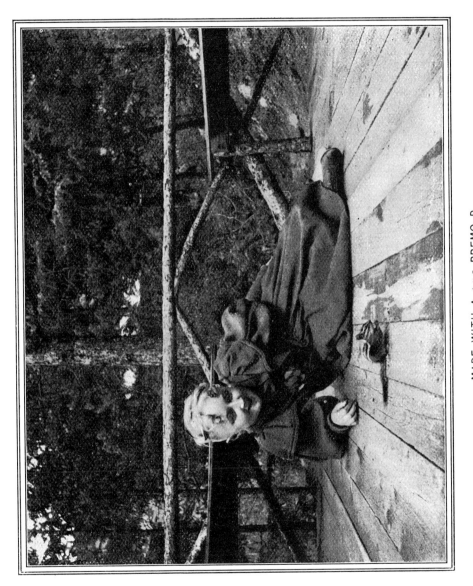

MADE WITH A 4 x 5 PREMO D.

The Premo D

Premo D is similar though made without the Swing Back.

The same care is exercised in its construction as in the others of the series, and this Camera will prove very popular, especially among many beginners, who prefer to invest, at first, but a moderate amount.

Premo D has Sliding Front for adjusting sky and foreground, and is fitted with Single Achromatic or Rapid Rectilinear Lens with Rotating Diaphragm. Our new Safety Shutter is also supplied, being a neat and effective device for both time and instantaneous work. The Shutter is set by a lever at the side, the leaves remaining stationary. Detailed description is given on page 83.

The ground glass screen on Premo D is spring acting, and recedes to allow the insertion of the plate holder. A hinged panel at the back permits the full sized image to be seen while focusing.

A brilliant Reversible View Finder is attached in a convenient position on the bed of the camera.

Two tripod plates are also fitted for both upright and horizontal pictures.

Premo D, is both compact and light in weight. When closed the 4 x 5 measures only 4⅝ x 5⅝ x 6⅞ inches, including space for three plate holders or roll holder, and it weighs but a trifle over two pounds. It is without question the best Folding Camera ever offered at so low a price.

Glass Plates, Cut and Roll Films may all be used. The Roll Holder is the latest pattern for Cartridge Film and can be loaded in daylight.

Price includes Camera, Lens, Shutter, and one Double Plate Holder.

PRICES :

		4 x 5	5 x 7
Premo D, with Achromatic Lens,	-	$10.00	$18.00
With Rapid Rectilinear Lens,	-	15.00	24.00
Extra Premo Plate Holders,	-	1.00	1.25
Cut Film Holder,	-	1.35	1.60
Cartridge Roll Holder, empty,	-	5.00	6.50
Light Proof Roll of Film,	12 Exposures, .90	12 Exp., 1.60	
Leather Covered Case,	-	2.50	3.00
Sole Leather Case,	-	3.50	4.00

THE PREMO V

PREMO V has been designed for the purpose of enabling those who are anxious to enjoy the pleasures of Amateur Photography—but wish to invest at first but a moderate amount in an outfit—"to try their hand" as it were. This camera will appeal very strongly to the novice in photography. So simple is the manipulation that anyone can readily operate it.

PREMO V is a thoroughly practical Camera—not a toy. It possesses many advantageous features entirely its own, and is, without question, the best instrument yet offered at so low a price.

It may be used to advantage for portraits, groups, marine and landscape views, in fact is adapted for the general work of amateur photographers.

PREMO V has a compartment at the back for three holders.

The Lens furnished with PREMO V is a Single Achromatic Lens, fitted with adjustable Diaphragms. It gives sharp definition, has a flat field, and is conceded to be the best of the moderate priced Lenses. It has a universal focus, no adjustment being necessary.

The Premo V is fitted with a new Safety Shutter adapted for both Time and Instantaneous Exposures. The speed can be governed by a small lever at the front.

The Premo V may be used on a tripod when desired. Two screw plates are fitted for both upright and horizontal pictures. Two view finders are also attached.

The Plate Holder is the Perfection Jr. with Registering Slides, recognized as the easiest holder to load and unload in the market.

Though moderate in price, Premo V is carefully made and free from all complicated parts. It is finished in black leather and has a neat leather handle for carrying. Instruction manual accompanies each Camera.

Price includes Camera complete with one Double Plate Holder.

PRICES :

Premo V, 3¼ x 4¼ or 4 x 5, - - - - - - - - - -	$5.00
Extra Plate Holders, each, - - - - - - - - -	1.00
Standard Tripod, - - - - - - - - - -	1.50
Developing and Printing Outfit, 3¼ x 4¼, - - - - - -	1.50
Developing and Printing Outfit, 4 x 5, - - - - - -	2.00

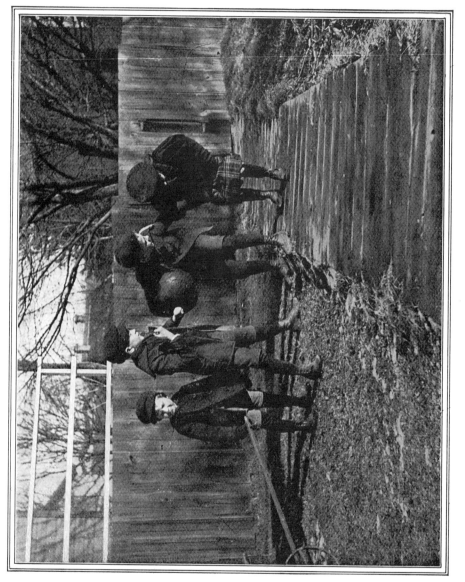

MADE WITH A 4 x 5 PONY PREMO E.

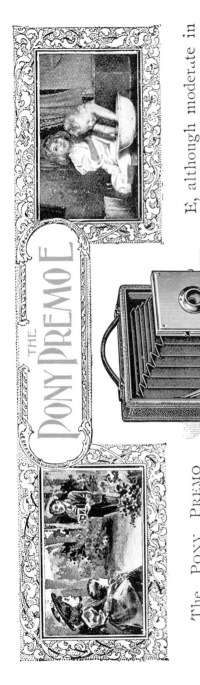

The PONY PREMO cost, is well made through-out of the best materials. It is constructed in a somewhat simpler form than the more expensive outfits, yet will be found a thoroughly practical Camera in every respect, and one that will meet with favor, particularly among the younger element of amateur photographers.

PONY PREMO E is handsomely finished, being shellaced inside and covered with black grained leather outside.

It is fitted with a fine Single Achromatic Lens, adjustable Diaphragms, and a New Safety Shutter operating for both time and Instantaneous Exposures. The Shutter is quickly set by simply turning a small milled head, the leaves remaining stationary.

51

The ground glass screen is spring acting, and recedes to allow the insertion of the plate holder. A hinged panel at the back permits the full sized image to be seen while focusing. A tripod plate is fitted for using the PONY E as a regular view Camera.

The View Finder is attached in a convenient position on the bed, and is reversible for both upright and horizontal pictures.

PONY PREMO E is very compact, measuring only 2 x 5¼ x 6 inches. It weighs but a trifle over one pound.

Glass Plates, and Cut Films may both be used, as the holders are interchangeable.

Pony Premo E is furnished with a neat leather covered case, made to contain the camera complete and three Plate Holders.

From the above description it will be seen that PONY E is fitted with the necessary adjustments for the varied character of work usually attempted by ambitious amateurs. We can heartily recommend it.

Price includes Camera, Lens, Shutter, Case and one Double Plate Holder.

PRICES:

	4 x 5
PONY PREMO E, - - - - - - - - -	$8.00
Extra Premo Plate Holders, - - - - - -	1.00
Cut Film Holders, - - - - - - -	1.35

52

MADE WITH A 5 x 7 PREMO B, RAPID RECTILINEAR LENS.

Owing to the cordial PONY PREMO we have this year adding several new designs reception given the PONY increased our assortment by at moderate prices.

The Pony Premo No. 2 is a thoroughly practical outfit, carefully made of the best materials, and will find favor among those who desire a first-class compact instrument at moderate cost.

The back of Premo No. 2 is made square, permitting an instant change of the plate from a horizontal to a vertical position, or *vice versa*, without disturbing the Camera. Heretofore the Reversible Back feature has only been applied to the more expensive instruments.

Pony Premo No. 2 has Sliding Front for adjusting sky and foreground, and is fitted with Single Achromatic or Rapid Rectilinear Lens with adjustable Diaphragms.

A New Safety Shutter is also supplied, being a neat and effective device for both time and instantaneous work. The Shutter is set by simply turning a milled head, the leaves remaining stationary.

The ground glass screen is spring acting, and recedes to allow the insertion of the plate holder. A hinged panel at the back permits the full sized image to be seen while focusing.

PONY PREMO No. 2 is very compact, measuring only 2¼ x 5⅞ x 5⅞ inches. It weighs but a trifle over two pounds.

Either Glass Plates, Cut or Roll Films may be used. The Roll Holder is the latest pattern, arranged for Cartridge or Light Proof Film, and may therefore be loaded in daylight.

The price includes Camera, Lens, Shutter, Carrying Case and one Double Plate Holder.

PRICES :

	4 x 5
PONY PREMO No. 2, with Achromatic Lens, - - -	$10.00
With Rapid Rectilinear Lens, - - - - -	15.00
Extra Premo Plate Holders, - - - - -	1.00
Cut Film Holder, - - - - - -	1.35
Cartridge Roll Holder, empty, - - - -	5.00
Light Proof Roll of Film, 12 exposures, - -	.90

55

MADE WITH A 4 x 5 PONY PREMO No. 3.

THE PONY PREMO No. 3

The Pony Premo 1898 Models, which we made and practical type, possessing modern approval of all who ate cost. It is admirably Wheelmen and Tourists generally, occupying but little space and withal easily operated.

No. 3 is another of our are confident will meet desire a thoroughly well Camera of the compact improvements, at moderadapted for the use of

Pony Premo No. 3 is fitted with a Reversible Back, thus allowing the operator to instantly change the plate from a horizontal to a vertical position, or *vice versa*, without in any way disturbing the Camera—a great convenience when the instrument is used on a tripod. The front is adjustable for varying the amount of sky or foreground.

57

PONY PREMO No. 3 is fitted with our well known Single Achromatic or Rapid Rectilinear Lens, with Rotating Diaphragm. It has the New Safety Time and Instantaneous Shutter, a neat and effective device for all classes of work.

A hinged door at the back permits the full sized image to be seen while focusing. A brilliant View Finder is conveniently located on the bed.

The PONY PREMO No. 3 is constructed of Mahogany, and handsomely covered with black leather. It is very portable, measuring only 2¼ x 5⅞ x 5⅞ inches when closed, and weighs but two pounds.

The Carrying Case is arranged to contain the Camera, with three Plate Holders or Roll Holder. Glass Plates, Cut or Roll Films may be used. The Roll Holder is arranged for Cartridge Film and can therefore be loaded in daylight.

Price includes Camera, Lens, Shutter, Case and one Double Plate Holder.

PRICES :

	4 x 5
Pony Premo No. 3, with Achromatic Lens, -	$12.00
With Rapid Rectilinear Lens, - - - -	17.00
Extra Premo Plate Holders, - - - -	1.00
Cut Film Holders, - - - - -	1.35
Cartridge Roll Holder, empty, - - -	5.00
Light Proof Roll of Film, 12 Exposures, - -	.90

58

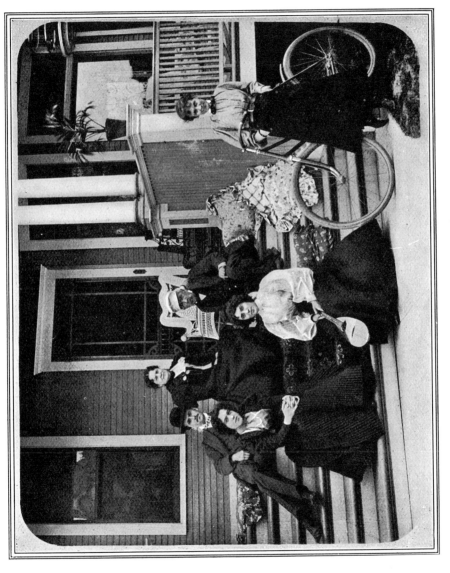

MADE WITH A 4 x 5 PONY PREMO No. 4.

THE
PONY PREMO № 4

In designing the aim has been to present a taining in the most containing features that appeal especially Tourists—yet at moderate

Pony Premo No. 4 our high-grade Camera, compact form all desirable especially to Wheelmen and cost.

This Camera represents in the Reversible Back Series what Premo B stands for in the regular style—a strictly high-grade outfit at a low price.

Pony Premo No. 4 is made of mahogany, trimmed with metal work of polished and lacquered brass. The outside is covered with fine black leather, and when opened the Camera presents a very handsome appearance.

The back of Premo No. 4 is Reversible, permitting an instant change of the plate from horizontal to a vertical position, or *vice versa*, without disturbing the Camera—a great convenience when using a tripod.

The front is adjustable for varying the amount of sky and foreground. The finder is placed in a convenient position on the bed.

PONY PREMO No. 4 is furnished with the Victor Shutter, for description of which see page 80. Either the Single Achromatic or Victor Rapid Rectilinear Lens is fitted, as may be preferred.

A hinged panel at the back permits the full sized image to be seen while focusing.

Glass Plates, Cut and Roll Films may be used, as the holders are interchangeable. The Roll Holder is of the latest design, arranged for Cartridge Film.

PONY PREMO No. 4 is very compact, measuring only $2\frac{3}{8}$ x $5\frac{7}{8}$ x $5\frac{7}{8}$ inches. It weighs but a trifle over two pounds.

Price includes Camera, Lens, Shutter, Case and one Double Plate holder.

PRICES :

	4 x 5
PONY PREMO No. 4, with Achromatic Lens,	$15.00
With Victor Rapid Rectilinear Lens,	20.00
Wide Angle Lens, extra,	10.00
Extra Premo Plate Holders,	1.00
Cut Film Holder,	1.35
Cartridge Roll Holder, empty,	5.00
Light Proof Roll of Film, 12 Exposures,	.90

THE PONY PREMO No. 5

In appearance and Premo No. 5 resembles good qualities, together ments of Double Sliding and Pinion movement cate focusing.

general design PONY Model 4, having all its with the additional adjust- Front and a fine Rack permitting the most deli-

While designed for the Wheelman and Tourist, yet PONY PREMO No. 5 will also meet the approbation of all to whom compactness is an important factor.

The Camera is constructed throughout of the finest mahogany, covered outside with handsome black leather. The trimmings are of polished and lacquered brass.

The back of PONY PREMO No. 5 is Reversible, thus permitting the operator to change the plate from a horizontal to a vertical position without disturbing the Camera—a great convenience when using a tripod.

The Lens is the Victor Rapid Rectilinear, fitted with the Victor Shutter, having pneumatic release and Iris Diaphragm. A description of both lens and shutter is given on pages 77 and 80.

The View Finder is located in a convenient position on the bed.

When desired the full sized image may be seen upon the ground glass screen by dropping the panel at the back.

The Roll Holder is of the most recent design, arranged for Cartridge or Light Proof Film. It can be loaded in daylight.

The Pony Premo No. 5 is furnished with a handsome leather case, made to contain Camera complete, with three Plate Holders or the Roll Holder. It may be attached to the frame of a bicycle or carried by means of the shoulder strap, as preferred.

The price includes Camera, Lens, Shutter, one Double Plate Holder and Case.

PRICES:

	4 x 5
Pony Premo No. 5, - - - - - - - - - -	$25.00
Wide Angle Lens, extra, - - - - - - - - -	10.00
Extra Plate Holders, each, - - - - - - -	1.00
Cut Film Holder, - - - - - - -	1.35
Cartridge Roll Holder, empty, - - - - -	5.00
Light Proof Roll of Film, 12 Exposures, - - -	.90

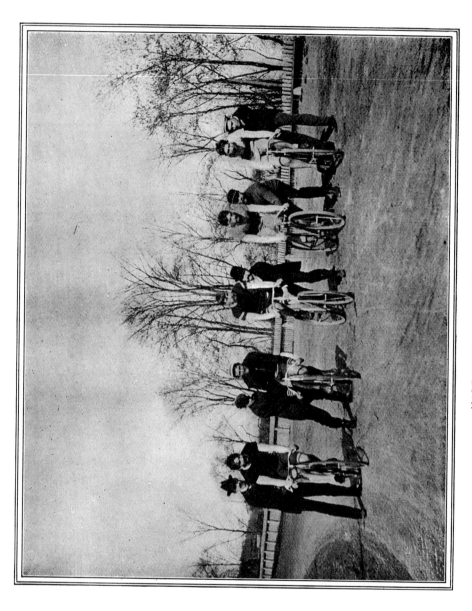

MADE WITH A 4 x 5 PONY PREMO.

THE PONY PREMO

THE PONY PREMO is of camera, presented for mere description utterly adequate idea of its real to be fully appreciated. a comparatively new form the first time in 1896. A fails to convey an merit. It must be seen Although extremely compact, every part is so perfectly adjusted, and works with such exquisite smoothness that the manipulation is a pleasure.

The 4 x 5 Pony Premo when closed measures only 5 x 6 x 2 inches, and weighs but 26 ounces.

Owing to its extreme portability and lightness of weight, this style Premo will of course appeal directly to Wheelmen and Tourists generally, yet we feel certain it will also find favor among a large class of amateurs desiring a thoroughly practical outfit to occupy the smallest possible space.

The Pony Premo is made throughout of seasoned mahogany. The entire camera is handsomely covered with fine black leather, and in contrast with the polished and lacquered brass trimmings and rich red leather bellows, presents an elegant appearance.

The back of the Camera is spring actuated, and recedes to allow the insertion of the Plate Holder. When Roll Films are used the Camera back, containing ground glass screen, is released from its spring supports, by a gentle pull to the right. It remains attached to the Camera, however, by means of two brass arms, which support the back at sufficient distance to allow the holder to slide in position, between the screen and the back frame of Camera.

The Lens is the Victor Rapid Rectilinear, made expressly for use with the Premo. It will be found well adapted for all classes of work. The Shutter is the Victor, fitted with Iris Diaphragm and pneumatic release. Both Lens and Shutter are fully described on pages 77 and 80.

A brilliant View Finder is conveniently located on the bed, and is reversible for upright or horizontal views.

The full sized image may be seen upon the ground glass when desired, by simply turning small button at the back.

The Pony Premo has adjustable front, and is adapted for use either in the hand or on a tripod.

The plate Holder is the Perfection Jr., the simplest and best double holder ever made. Its weight is but 2 ounces, yet it is perfectly strong and durable.

The Pony Premo is furnished with a neat sole leather Case, as shown in the illustration. It will hold Camera, Lens, Shutter, three Plate Holders or Roll Holder, and may be carried by the Shoulder Strap or attached to the frame of a bicycle in the same manner as a tool bag.

The Roll Holder is the latest pattern arranged for Cartridge Film, and may be loaded in daylight.

The price includes Camera, Lens, Shutter, one Double Plate Holder, and Sole Leather Case with Strap.

PRICES:

	3¼ x 4¼	4 x 5	5 x 7
Pony Premo, - - - - -	$22.00	$22.00	$30.00
Wide Angle Lens, extra, - - -		10.00	12.00
Extra Plate Holders, - - -	1.00	1.00	1.25
Cut Film Holders, - - -	1.35	1.35	1.60
Cartridge Roll Holder, empty, - -	5.00	5.00	6.50
Light Proof Roll of Film, 12 Exposures,	.75	.90	1.60

THE PONY PREMO A

Though only introduced by the Pony Premo A, meet with a reception tendered its predecessor.

duced in 1896, the success Premo has led us to present the Pony feeling assured it will equally as cordial as that achieved by the Pony

While designed for the Wheelman and Tourist, yet Pony Premo A will also meet the approbation of all, to whom extreme compactness is an important factor, and we are confident this pattern will prove one of the most popular styles yet devised—especially among lady amateurs, who will appreciate its dainty appearance, portability and ease of manipulation.

In general design Pony Premo A resembles the original model, possessing all its good qualities, together with the additional adjustments of Double Sliding Front, and Rack and Pinion movement, permitting the most delicate focusing.

The Camera is constructed throughout of the finest mahogany, covered outside with handsome black leather. The metal trimmings are of polished and lacquered brass.

The Lens is the Victor Rapid Rectilinear, fitted with Victor Shutter, detailed description of which is given on pages 77 and 80.

When desired the full sized image may be seen upon the focusing screen, by turning a small button at the back. The Plate Holder is the Perfection Jr.

The Roll Holder is of the most recent design, arranged for Cartridge Rolls of Film. It can be loaded in daylight.

The Pony Premo A is furnished with a handsome sole leather case, made to contain camera complete, with three Plate Holders or the Roll Holder. It may be attached to the frame of a bicycle or carried by means of the shoulder strap as preferred.

The price includes Camera, Lens, Shutter, one Plate Holder and Case.

PRICES:

	4 x 5	5 x 7
Pony Premo A, - - - - - - - - - -	$25.00	$35.00
Wide Angle Lens, extra, - - - - - -	10.00	12.00
Extra Plate Holders, - - - - - - -	1.00	1.25
Cut Film Holder, - - - - - - -	1.35	1.60
Cartridge Roll Holder, empty, - - -	5.00	6.50
Light Proof Roll of Film, 12 Exposures, - -	.90	1.60

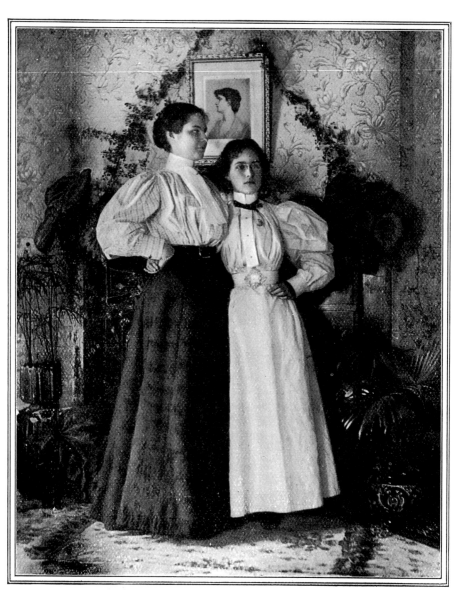

MADE WITH A 4 x 5 PONY PREMO SR.

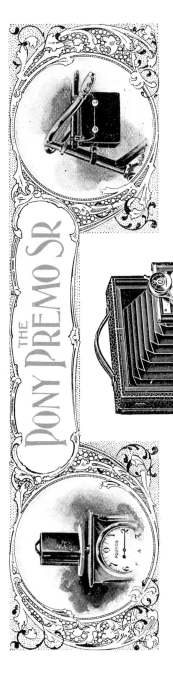

The Pony Premo
lar pattern, in general
the additional adjust-
Back, Rising and Sliding
Pinion movement for fo-
for every variety of work. Like the regular style, the Pony Premo
and used in order to fully demonstrate its many meritorious features.
manipulation, extreme compactness, portability and fine finish, will commend it
to every amateur and professional photographer desiring a camera of the most
compact form, and strictly up-to-date in every particular.

Sr. is similar to the regu-
design. It has, however,
ments of Double Swing
Front, and Rack and
cusing, thus adapting it
Sr. must be seen
The ease of

The 4 x 5 Pony Premo Sr. measures only 5¾ x 6¾ x 2⅜ inches when closed,
and weighs 34 ounces. Its portability and lightness of weight will render it excep-
tionally popular among Wheelmen and Tourists generally.

The Lens is the Victor Rapid Rectilinear, fitted with the Victor Shutter, having pneumatic release and Iris Diaphragm. A description of both Lens and Shutter is given on pages 77 and 80.

The full sized image can be seen upon the ground glass by turning the small button at the back.

The plate holder is the Perfection Jr.—the simplest and easiest to operate of any in the market.

The Roll Holder is the latest style for Cartridge Film.

The Pony Premo Sr. is furnished with a handsome sole leather case, made to carry the Camera complete with three plate holders or Roll Holder. It can be attached to a bicycle in the same manner as a tool bag, or carried by the shoulder strap, as preferred.

The price includes Camera, Lens, Shutter, one Double Plate Holder and Carrying Case with Strap.

PRICES :

	3¼ x 4¼	4 x 5	5 x 7	6½ x 8½
Pony Premo Sr., - - -	$28.00	$28.00	$38.00	$48.00
Wide Angle Lens, extra, -		10.00	12.00	15.00
Extra Plate Holders, - -	1.00	1.00	1.25	1.60
Cut Film Holder, - -	1.35	1.35	1.60	1.85
Cartridge Roll Holder, empty,	5.00	5.00	6.50	12.00*
Light Proof Roll of Film 12 Exposures, .75		12 Exp. .90	12 Exp. 1.60	24 Exp., 4.00
				48 Exp., 8.00

*Not made for Cartridge Film.

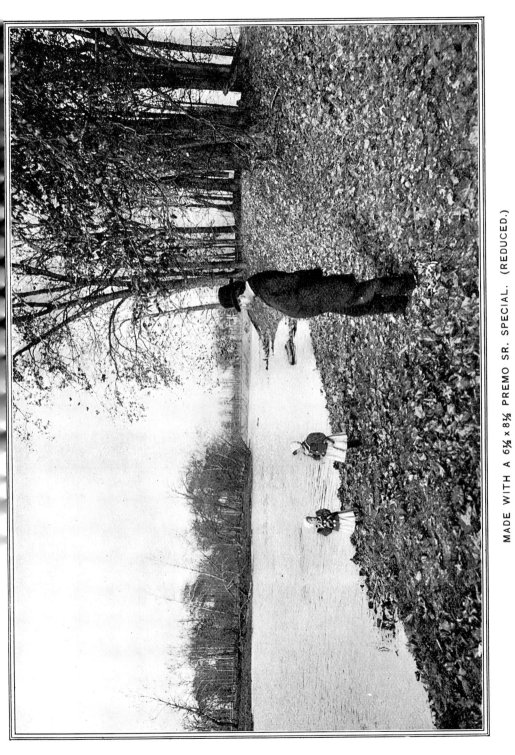

MADE WITH A 6½ x 8½ PREMO SR. SPECIAL. (REDUCED.)

Price List of Premo Cameras.

	3¼ x 4¼	4 x 5	5 x 7	6½ x 8½	8 x 10
Premo A,	$ 25.00	$ 25.00	$ 33.00	$ 42.00	$ 60.00
Premo Sr.	30.00	30.00	40.00	50.00	65.00
Reversible Back Premo Sr.		35.00	45.00	55.00	65.00
Long Focus Premo,	35.00	35.00	45.00	55.00	72.00
Reversible Back Premo,		40.00	50.00	62.00	
Premo Sr. Special,		67.00	84.00	103.00	120.00
Long Focus Premo Special		85.00	100.00	132.00	170.00
Stereo Premo A,			70.00	80.00	
Stereo Premo Sr.,			75.00	85.00	
Stereo Long Focus Premo,			80.00	90.00	
Premo B, Achromatic Lens,		15.00	23.00		
Premo B, Rectilinear Lens,		20.00	30.00		
Premo C, Achromatic Lens,		12.00	20.00		
Premo C, Rectilinear Lens,		17.00	26.00		
Premo D, Achromatic Lens,		10.00	18.00		
Premo D, Rectilinear Lens,		15.00	24.00		
Premo V,	5.00	5.00			
Pony Premo E,		8.00			
Pony Premo No. 2, Achromatic Lens,		10.00			
Pony Premo No. 2, Rectilinear Lens,		15.00			
Pony Premo No. 3, Achromatic Lens,		12.00			
Pony Premo No. 3, Rectilinear Lens,		17.00			
Pony Premo No. 4, Achromatic Lens,		15.00			
Pony Premo No. 4, Rectilinear Lens,		20.00			
Pony Premo No. 5,		25.00			
Pony Premo		22.00	30.00		
Pony Premo A.		25.00	35.00		
Pony Premo Sr.,	28.00	28.00	38.00	48.00	

Price List of Premo Cameras.

With Victor Lens and B. & L. Diaphragm Shutter.

	3¼ x 4¼	4 x 5	5 x 7	6½ x 8½	8 x 10
Premo A, - - - -	$32.00	$32.00	$41.00	$51.00	$69.00
Premo Sr., - - - -	37.00	37.00	48.00	59.00	
Long Focus Premo, - -		42.00	53.00	64.00	74.00
Reversible Back Premo, -		47.00	58.00	71.00	81.00

Price With Rapid Universal Lens.

VICTOR SHUTTER.

	4 x 5	5 x 7
Premo A, - -	$36.00	$48.00
Premo Sr., -	41.00	55.00
Long Focus Premo,	46.00	60.00
Rev. Back Premo, -	51.00	65.00

B. & L. DIAPHRAGM SHUTTER.

	4 x 5	5 x 7	6½ x 8½	8 x 10
Premo A, - -	$43.00	$56.00	$72.00	$ 95.00
Premo Sr., -	48.00	63.00	80.00	100.00
Long Focus Premo,	53.00	68.00	85.00	100.00
Rev. Back Premo, -	58.00	73.00	92.00	107.00

Price With Zeiss Convertible Lens, Series VIIA, and Diaphragm Shutter.

	4 x 5	5 x 7	6½ x 8½	8 x 10
	No. 3 Lens.	No. 8 Lens.	No. 12 Lens.	No. 14 Lens.
Long Focus Premo, - - - - -	$ 97.00	$121.00	$169.00	$189.00
Reversible Back Premo, - - -	102.00	126.00	176.00	196.00

75

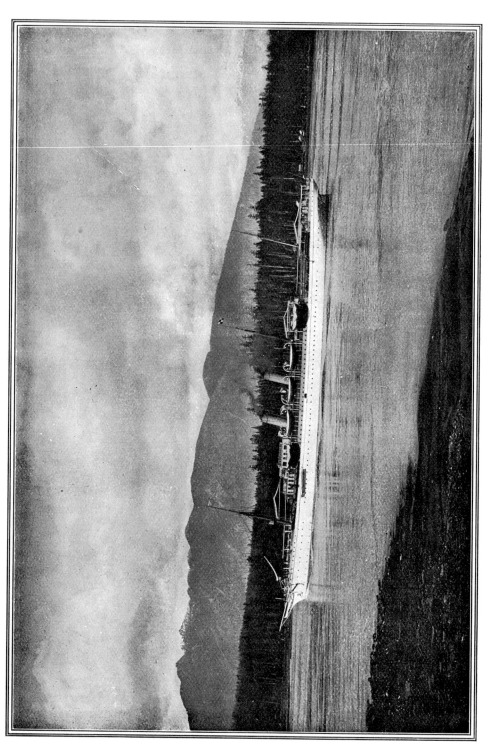

R. M. S. EMPRESS OF INDIA. MADE WITH 5x7 PREMO SR. SPECIAL. (REDUCED.)

THE PREMO LENSES

While it is true that the camera box is a very important part of the equipment, the fact is self evident, that upon the quality of the Lens, depends in a large measure the success of the amateur photographer. Just as the human eye is the entrance of light to the body, so is the Lens of a camera the factor, by which either a perfect or inferior impression of the objects within its range, is reflected on the sensitive plate. In selecting a camera, therefore due consideration should be given to the Lens.

THE VICTOR RAPID RECTILINEAR LENS furnished with the Premo Cameras, is very carefully and accurately made. It is manufactured especially for Hand Camera work, and will be found admirably adapted for general photography, such as portraits, groups, architectural subjects, landscapes, etc. It possesses ample speed for rapid instantaneous exposures, a flat field, depth of focus, good covering power, and freedom from distortion.

THE SINGLE ACHROMATIC LENS furnished with the various Premos is conceded to be the best of the moderate priced Lenses. It gives wonderful definition with great depth of focus and flatness of field. Though not adapted to such a large variety of work as the Rapid Rectilinear Lens, it nevertheless possesses ample speed, and will be found very satisfactory for general amateur use.

THE VICTOR WIDE ANGLE LENSES are interchangeable with the Victor Rapid Rectilinear, and may therefore be used in the Victor Shutter, when so desired. They are particularly valuable for interiors and architectural effects in confined situations. Having a greater angle than the Rectilinear form of Lens, they admit of being nearer the object photographed. Wide Angle Lenses are not so quick working as those of ordinary angle. The principal objection, however, to their more general use is the fact that on account of the increased angle the perspective is necessarily exaggerated.

Premo Cameras are always fitted with the ordinary Angle Lens. The additional cost for the Wide Angle is given under the description of Camera.

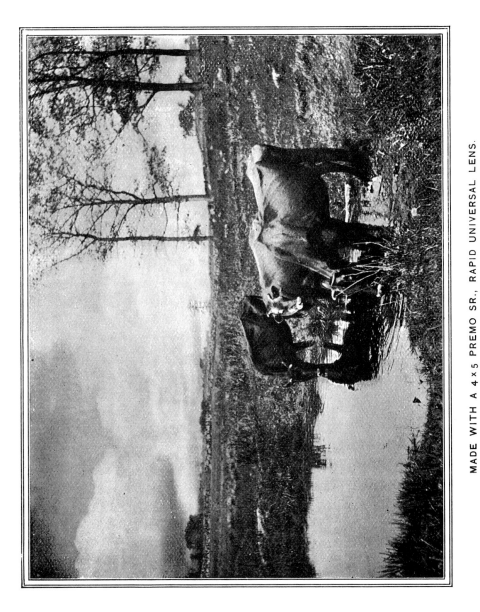

MADE WITH A 4 x 5 PREMO SR., RAPID UNIVERSAL LENS.

THE VICTOR SHUTTER

THE VICTOR SHUTTER is a marvel of ingenuity. All the latest and most approved adjustments, including the Iris Diaphragm, have been added, making it complete in every detail. It works between the lenses, and may be easily and quickly regulated for time and instantaneous exposures. The Shutter is practically noiseless, and perfectly free from vibration. Both pneumatic and finger release are fitted.

The Iris Diaphragm, as applied to the Victor Shutter, is an important feature, and is the best adjustment for regulating the amount of light entering the lens yet devised. By simply moving the lever C to the right or left, the size of the aperture is increased or diminished. The movement of the leaves of the Iris is very smooth, and the size of each opening is indicated by an index and scale on the margin of the shutter.

The manipulation of the Shutter is very simple. To set for instantaneous work, move the lever A to the left, (shutter facing you) until a "click" is heard. It will then occupy the position shown by dotted lines. The exposure is made by a gentle

pressure on release lever D, or with the bulb, as preferred. The leaves always remain closed when setting.

The Victor Shutter works automatically from 1 second to fractional parts of a second. The speed may be varied at will by simply revolving the numbered metal disc at top, to the right or left, until the index is opposite the speed desired.

Time exposures are made by turning the numbered disc so the pointer will be opposite the letter T. Then push lever A to the left as directed for instantaneous work. Pressure on the release lever D or the bulb will open the Shutter; a second pressure will close it.

When the pointer is at the letter B the Shutter will remain open so long as a pressure is exerted on the bulb. When pressure is removed the Shutter closes.

THE PREMO WITH
B. & L. DIAPHRAGM SHUTTER.

The Bausch & Lomb Diaphragm Shutter may be attached to the Premo A, Premo Sr., both styles, Pony Premo Sr., Long Focus and Reversible Back Premos in place of the Victor if preferred.

The Diaphragm Shutter will operate automatically from three seconds to the one hundredth part of a second, and by simply moving a small lever it may be set for time exposures of any desired duration. It is constructed in the very best manner, and works without noise or jar, even when set at the highest speed.

For price list of Premo Cameras fitted with Diaphragm Shutter see page 75.

MADE WITH A PREMO SR.

THE NEW SAFETY SHUTTER

Pony Premo No. 3, also Premos C and D are fitted with a new Safety Shutter, an exceedingly neat and effective device for both time and instantaneous exposures.

While not so elaborate as the "Victor," it is well adapted for the general work of the amateur. Its motion is perfectly smooth, being entirely free from vibration and jar.

The Shutter is set by simply moving a spring lever at the side, the plate always being covered. Exposure is made by a gentle pressure on the release button. The speed may be varied from one-tenth to one-fiftieth of a second, depending on the position of the milled wheel at the side. As the wheel is revolved *downward* the speed of the shutter is accelerated, and by reversing the motion, the tension is reduced, thus decreasing the speed. The letters F and S stamped on the wheel indicate whether the shutter is set for a fast or slow movement.

Time exposures of any desired duration are made by a simple adjustment of the release button.

A manual containing complete instructions for manipulation accompanies each camera.

The Plate Holder

Premo Cameras are furnished with the Perfection Jr. Plate Holder, conceded to be the most efficient, durable and easiest to operate of any Holder in the market without exception. It is fitted with our patent spring bar, by means of which the Holder may be readily loaded in the dark—so simple is the operation. The Perfection Jr. is extremely compact and very light, the 4 x 5 weighing only two ounces. Kits for smaller sized plates may be used when desired. All holders are fitted with a safety catch, preventing the slides being accidentally withdrawn.

ROLL HOLDER FOR FILMS. Premo Cameras are adapted for both Glass Plates and Roll Films. The Roll Holder, which is necessary for the use of film, is not included in the price, as most of our customers prefer to use plates. Unless you contemplate a long journey we would advise the purchase of the Premo with plate holders only, for the start at least. You can purchase a Roll Holder at any subsequent time, and it will fit the Camera perfectly. For a long trip, however, where you desire to make a large number of exposures before developing, films will be found very convenient, being lighter than glass and more portable.

All 4 x 5 and 5 x 7 Premo Roll Holders are arranged for Cartridge or Light Proof Film, and can be loaded or unloaded in daylight.

DEVELOPING AND PRINTING

Many amateur photographers are satisfied with merely "taking" a picture, and prefer to have the developing and finishing done for them. While, in our opinion, very much of the pleasure in photography is lost by this method, yet for those who do not care to investigate the mysteries of the dark room, we have provided a Finishing Department with ample facilities for the prompt execution of all orders. This work you can also have done by your local photographer, and in fact we recommend this course if you are using glass plates.

PRICE LIST FOR DEVELOPING AND PRINTING.

Size of Camera.	Developing, Printing and Mounting.	Developing Only.	Printing and Mounting Only.
3¼ x 4¼	12 cents.	6 cents.	8 cents.
4 x 5	15 "	8 "	10 "
5 x 7	20 "	10 "	12 "
5 x 8	20 "	10 "	12 "
6½ x 8½	25 "	10 "	17 "
8 x 10	35 "	15 "	25 "

COMPLETE DEVELOPING AND PRINTING OUTFITS.

For the large number of amateurs who prefer not only to "take" pictures, but finish them as well, we have arranged the following complete outfits, comprising all necessary articles for developing the negative and making the print.

OUTFIT No. 1.

3 Tin Developing Trays.
½ dozen Dry Plates.
1 R. O Compact Candle Lamp.
1 Bottle Hydrogen Developer.
1 Glass Graduate.

1 Printing Frame.
1 dozen Aristotype Paper.
1 Bottle Toning Solution.
½ pound Hypo Sulphite Soda.
1 dozen Card Mounts.

	4 x 5	5 x 7
Price, neatly boxed, - - -	$2.00	$3.25

OUTFIT No. 2.

This outfit contains a greater variety of accessories than No. 1, and a larger quantity of plates, chemicals, etc. It includes

3 Jap. Tin Developing Trays.
1 dozen Dry Plates.
1 Glass Graduate.
1 Box Hydrogen Developer.
1 pound Hypo Sulphite Soda.
1 Jar Cream Paste.

1 Universal Ruby Lantern.
1 Favorite Printing Frame.
1 dozen Aristotype Paper.
1 Bottle Toning Solution.
25 Card Mounts.
1 copy *Amateur Photographer.*

	4 x 5	5 x7	6½ x 8½	8 x 10
Price, - - - -	$4.00	$4.75	$6.00	$7.50

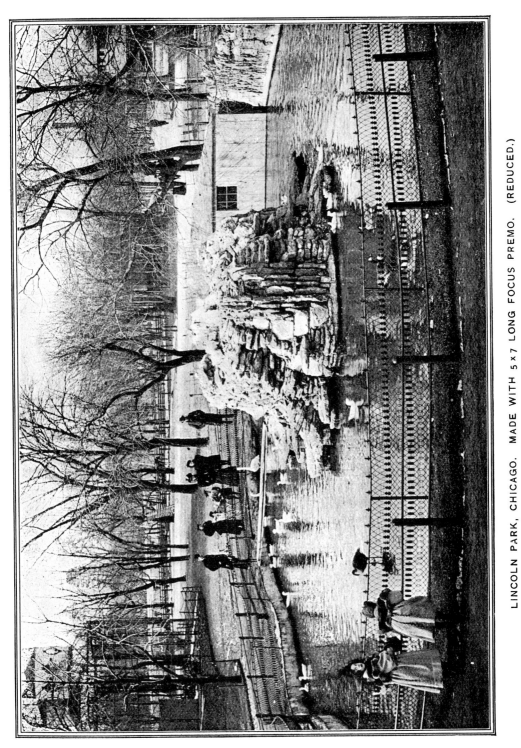

LINCOLN PARK, CHICAGO. MADE WITH 5 x 7 LONG FOCUS PREMO. (REDUCED.)

The Premo Tripod

This new Tripod is designed especially for use with Hand Cameras. It is the lightest and most compact form ever made, yet is rigid and perfectly durable in all its parts.

The Premo Tripod is made with three joints. The lower section slides into the second, and these two into the third, while the upper section folds back upon the third.

When closed it measures only 16 inches long, and the No. 1 weighs but 15 ounces, including the Aluminum top. The length extended is 55 inches. It is quickly set up for use and readily adjusted for height by means of a milled head. The legs of the Tripod may be grasped at the top for the purpose of changing its position, without fear of separating them from the head.

No. 1—For 4 x 5 Cameras, weight 15 ounces, - $4.50
No. 2—For 5 x 7 Cameras, weight 1 pound 7 ounces, 5.00

THE PETITE TRIPOD

THE PETITE TRIPOD is another new form made expressly for Hand Camera use. Its construction is somewhat similar to the Premo, being made with three joints, but the top remains attached.

The Petite Tripod is exceedingly compact, the length when closed being only 16¼ inches. When extended for use the length is 55 inches. Weight only 17 ounces complete. The construction of the Petite Tripod renders it not only compact, but rigid as well, and it is without question one of the best tripods yet introduced.

Petite Tripods are thoroughly well made from the best seasoned spruce, and handsomely finished with polished and lacquered brass trimmings.

No. 1—For 4 x 5 and 5 x 7 Cameras, - $5.00

89

The Combination Tripod

The Combination Tripod is one of the most convenient forms yet devised. It is quickly set up for use and readily adjusted at any desired height.

It is made in three sections ; the lower section slides into the second, while the upper section folds back upon it.

Combination Tripods are constructed from fine spruce, with brass trimmings, and are perfectly rigid and durable.

The top is provided with an ingenious device which prevents the legs from becoming accidentally detached when in position for use.

Extended length, 56 inches ; length closed, 22 inches.

No. 0—Spruce, for 4 x 5 Cameras, weight 1 pound, - $2.75
No. 1—Spruce, for 5 x 7 Cameras, weight 1 pound 6 ounces, - - - 3.00
No. 2—Spruce, for 6½ x 8½ Cameras, weight 1 pound 9 ounces, - - - 3.25

The Facile Sliding Tripod

In presenting the Facile Tripod, a new design this year, we are confident that we are offering the neatest and altogether the best moderate priced tripod in the market.

The lower section of the Facile is made to slide into the upper, and by means of a neat milled head is held at any desired height.

The Facile Tripod is constructed of fine quality spruce, with trimmings of polished and lacquered brass.

A neat hook is attached to each leg, which makes it impossible for them to become disconnected from the head when tripod is in use. The head may be removed however, if desired.

When closed the Facile measures only 30 inches long. Extended for use the length is 57 inches.

No. 1—For 4 x 5 and 5 x 7 Cameras, weight 17 ounces, $2.00
No. 2—For 6½ x 8½ Cameras, weight 1 pound 9 ounces, 2.25

THE COMPACT CANDLE LANTERN.

The COMPACT CANDLE LANTERN is a new design in collapsable lamps, and is intended more especially for use when traveling. The top and bottom may both be removed and packed with the body of the lamp in a box measuring only one inch in depth.

There is no glass to break, ruby fabric being used instead. The Compact Candle Lantern will be found a desirable addition to any outfit.

Price, with Wax Candle, - $0.40

THE UNIVERSAL DARK ROOM LANTERN.

The UNIVERSAL is the most popular moderate priced Lantern in the market. The ventilation is perfect and the volume of light ample.

The Universal is made in two sizes. The No. 2 is larger than No. 1, and has both orange and ruby glass. The body is hinged at the back, while in the No. 1 the glass is raised in the slide to light the wick. In both sizes the flame is controlled from the outside, and an adjustable shield protects the eyes, throwing light directly on the developing tray.

Price, No. 1, - $0.80 | Price, No. 2, $1.00

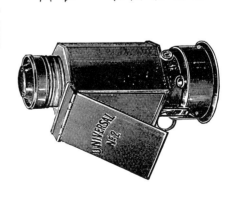

THE GEM RUBY LAMP.

The GEM RUBY LAMP is one of the neatest lamps for dark-room purposes ever placed on the market. It gives an abundance of safe light for all the purposes of the ordinary amateur, and the ruby chimney being round, the light is emitted in all directions.

The chimney is provided with a removable metal top, which prevents the radiation of any white light.

To light the Gem Lamp, the ruby chimney is removed, same as an ordinary house lamp.

Price, - - $1.00

THE CARLTON LANTERN.

The CARLTON LANTERN is made upon an improved plan, giving an abundant draft, and complete ventilation, hence no smoke, no fume, but a steady, safe light, *and plenty of it.*

The front is fitted with both Orange and Ruby glass. The body is hinged at the back, giving easy access to the interior. The flame is regulated entirely from the outside. The back of the lamp serves as a reflector, and aids in producing a volume of light sufficient for work in any dark-room. Made in two sizes.

Price, No. 1, - - $1.50 | Price, No. 2, - - $2.00

JAPANNED TIN DEVELOPING TRAYS.

4 x 5	-	-	-	$0.20	6½ x 8½	-	-	$0.30
5 x 8	-	-	-	.25	8 x 10,	-	-	.40

VULCANIZED RUBBER TRAYS.

The neatest Developing Tray yet introduced is that made from vulcanized rubber. It has a polished surface, thus it is readily kept clean.

		SHALLOW.	DEEP.			SHALLOW.	DEEP.
4 x 5,	-	$0.30	$0.40	6½ x 8½,	-	$0.75	$0.80
5 x 8,	-	.60	.65	8 x 10, -	-	1.10	1.15

COMPRESSED FIBER TRAYS.

FOR DEVELOPING, FIXING AND TONING.

Fiber Trays are light in weight, yet tough and strong. As they are not affected by the action of chemicals, and easily kept clean, we recommend them for all purposes. The deep trays have a lip.

		SHALLOW.	DEEP.			SHALLOW.	DEEP.	
4 x 5,	-	$0.25	$0.40	6½ x 8½,	-	$0.60	$0.65	
5 x 7,	-	-	.45	.55	8 x 10,	-	.85	.95

95

CARLTON'S HYDROGEN DEVELOPER.

HYDROGEN DEVELOPER is a combination of Hydrochinon and Eikonogen, possessing the good qualities of both. The proportions are so well balanced that the results on any make of plates show the detail and exquisite softness of the Eikonogen, together with the crispness and density of the Hydrochinon.

Hydrogen Developer never becomes thick, and will not stain either the plate or fingers.

Price,	8-oz. bottle,	- - - - - - -	$0.30
"	16-oz. "	- - - - - - -	.50
"	32-oz. "	- - - - - - -	.90

CARLTON'S PYRO-POTASH DEVELOPER.

CONCENTRATED.

We claim for this developer that more can be done with a plate than almost any developer in the market; the operator has almost perfect control over the plate, and brilliant negatives are the rule. Put up in two 8-oz. bottles, in card-board box.

Per box, - - - - - - - $0.60

CARLTON'S HYDROCHINON DEVELOPER.

CONCENTRATED.

Will not stain the fingers or plate; gives clear shadows; especially desirable for transparencies. Can be used over and over again.

Put up in two 8-oz. bottles, in card-board box.

Per box, - - - - - - - $0.50

DRY PLATES.

We sell several makes of Dry Plates, among them being Forbes', Record, Cramer's, Seed's, Carbutt's and Stanley's.

3¼ x 4¼, per doz., - $0.45 5 x 8, per doz., - $1.25
4 x 5, " - .65 6½ x 8½, " - 1.65
5 x 7, " - 1.10 8 x 10, " - 2.40
3¼ x 4, Transparency Plates, for Lantern Slides, per doz., - .65

ARISTOTYPE PAPER.

		SPECIAL.		ARISTO.		MATTE.	
		Dozen.	Gross.	Dozen.	Gross.	Dozen.	Gross.
3¼ x 4¼,	-	.10	.65	.20	1.20	.20	1.60
4 x 5,	-	.12	1.00	.25	1.50	.25	2.00
3⅞ x 5½, Cabinet,	-	.12	.75	.25	1.00	.25	2.00
4¼ x 6½,	-	.15	1.40	.30	2.00	.30	2.50
5 x 7,	-	.20	1.75	.35	2.65	.40	3.50
5 x 8,	-	.25	2.00	.40	3.00	.45	4.00
6½ x 8½,	-	.35	3.00	.55	4.10	.65	6.00
8 x 10,	-	.45	4.00	.75	6.00	.90	8.00

FERRO-PRUSSIATE OR BLUE PAPER.

Put up in light-tight packages of two dozen sheets.

3¼ x 4¼, per package, - $0.20 5 x 8, per package, $0.40
4 x 5, " " - .20 6½ x 8½, " " .50
5 x 7, " " - .35 8 x 10, " " .75

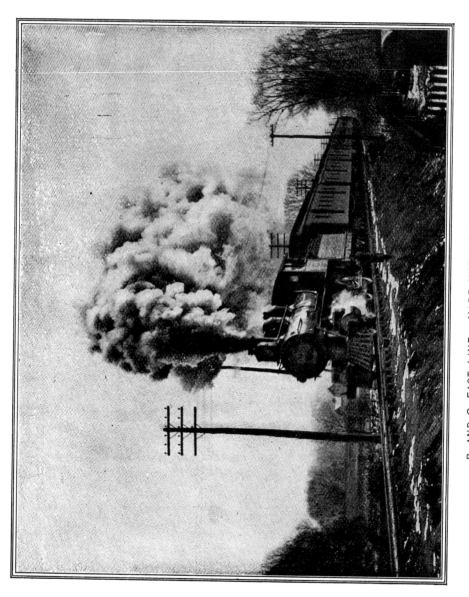

B. AND O. FAST LINE. MADE WITH THE PREMO SR

CARD MOUNTS.

☞ When mounts are ordered sent by mail, postage must accompany the order. The amount to add per Package for postage on the different sizes, is as follows : 3¼ x 4¼, 13 cents ; 4 x 5, 15 cents ; Cabinet, 17 cents ; 4¼ x 6½ and Stereoscopic, 19 cents ; 5 x 7, 20 cents ; 5 x 8, 26 cents ; 6½ x 8½, 37 cents ; 8 x 10, 45 cents.

No. 1.—Plain, Round Edge, White, Rose or Primrose.

	Per package of 25.	Per 100		Per package of 25.	Per 100
3¼ x 4¼,	$0.18	$0.65	5 x 7,	$0.30	$0.95
4 x 5,	.20	.70	5 x 8,	.35	1.10
Cabinet,	.25	.80	6½ x 8½,	.50	1.50
4¼ x 6½ or Stereo,	.30	.85	8 x 10,	.70	2.25

No. 2.—White, Rose or Amber, with Gilt Beveled Edge.

	Per package of 25.	Per 100		Per package of 25.	Per 100
3¼ x 4¼,	$0.25	$0.80	5 x 7,	$0.50	$1.75
4 x 5,	.30	.95	5 x 8,	.55	1.90
Cabinet,	.30	1.00	6½ x 8½,	.80	2.75
4¼ x 6½ or Stereo,	.45	1.50	8 x 10,	1.00	3.40

No. 4.--Unenameled, Narrow Embossed Border, Assorted Colors, White, Primrose, Pearl, Gray and Rose.

	Per Package of 25.	Per 100		Per Package of 25.	Per 100
4 x 5,	$0.35	$1.20	5 x 7,	$0.65	$2.25

No. 5.—Unenameled, Wide Embossed Border, Assorted Colors, White, Gray, Tea and Steel Gray.

	Per Dozen.	Per 100		Per Dozen.	Per 100
3¼ x 4¼ or 4 x 5,	$0.25	$1.75	5 x 7,	$0.35	$2.50

99

CHEMICALS.

Carlton's Aristo Toning and Fixing Solution,	-	-	8 oz. bottle, $0.40 ;	16 oz. bottle, $0.75				
Carlton's Intensifier,	-	-	4 oz.	"	.25 ;	8 oz.	"	.40
Carlton's Negative Varnish,	-	-	4 oz.	"	.30 ;	8 oz.	"	.50
Hypo-Sulphite Soda, (1 lb. box),	-	-	-	each, .10				
" " (5 lb. box),	-	-	"	.40				
Pyrogallic Acid,	-	-	per ounce, .40					
Hydrochinon,	-	-	" " .40					
Eikonogen,	-	-	" " .40					
Meta Bisulphite of Potash,	-	-	" " .30					
Carbonate of Soda,	-	-	per pound, .15					
Carbonate of Potash,	-	-	" " .25					
Sulphite of Soda,	-	-	" " .25					
Chloride of Gold, (15 grain bottle)	-	-	each, .60					
Acetate of Soda, (2 oz. bottle),	-	-	" " .20					
Bromide Ammonia,	-	-	per ounce, .15					
Sulpho-Cyanide of Ammonia,	-	-	" " .20					
Bi Carbonate of Soda,	-	-	" " 5					
Borax,	-	-	" " 5					
Tungstate of Soda,	-	-	" " .15					
Chloride of Lime,	-	-	" " 5					
Magnesium Powder,	-	-	" " .40					

General Premo Accessories.

PRINTING FRAMES.

3¼ x 4¼,	-	$0.40
4 x 5,	-	.40
5 x 7,	-	.50
6½ x 8½,	-	.60
8 x 10,	-	.75

GLASS GRADUATES.

Minim,	-	.25
1 oz.,	-	.20
2 oz.,	-	.25
4 oz.,	-	.30
8 oz.,	-	.40
12 oz.,	-	.55

FLUTED GLASS FUNNELS.

½ pint,	-	.15
1 "	-	.20
1 quart,	-	.30
2 "	-	.45

POCKET SCALES.

5-inch beam,	-	.60
6-inch "	-	.75

FLASH LAMPS.

Perfection,	-	$2.00
Hale's,	-	1.50

BRISTLE BRUSHES.

1-inch wide,	-	.15
1½-in. "	-	.20
2-inch "	-	.25

CAMELS HAIR BRUSHES.

1-inch wide,	-	.25
1½-in. "	-	.40
2-inch "	-	.50

CREAM PASTE.

¼-pint jar,	-	.20
½ " "	-	.25
1 " "	-	.35
Negative Rack,	-	.40
Ferrotype Plates, for drying Aristotype and other papers with glossy surface, each,	-	.15
Double Roller Squeegee, 6-inch,	-	1.00
1 dozen Blotting Paper, 9 x 12,	-	.25

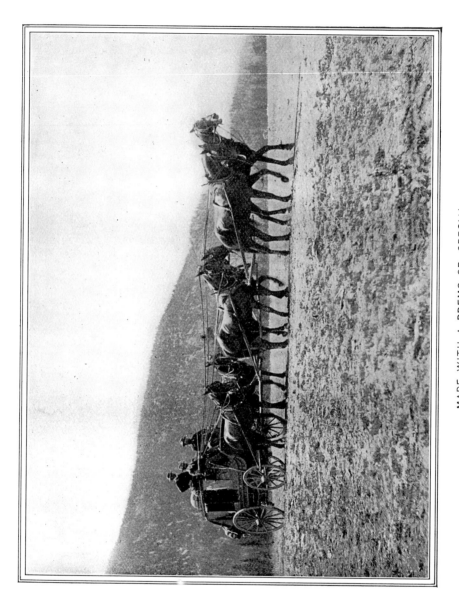

MADE WITH A PREMO SR. SPECIAL.

Terms.

Prices given are net, no charge for boxing or cartage.

We prefer that remittances be made by draft on New York, Post Office or Express Order, or Registered Letter. Bank Checks, when from parties unknown to us, *unless certified* by the bank on which they are drawn, will delay shipment of goods, until the check can be collected through our bank. Fifteen cents must be added for cost of exchange.

Persons unknown to us, desiring goods sent C. O. D., must remit one-quarter the cost with the order. The goods will then be sent by express, with the privilege of inspection; should they not be kept, we will return the amount of remittance, less express charges.

Orders for shipment by freight must be accompanied by full amount of invoice.

We pack all goods with the utmost care, and will guarantee their safe arrival when sent by freight or express.

Small parcels, which do not contain glass, can be sent by mail if desired, but, *must be sent at risk of purchaser*. In ordering goods sent by mail, postage *must be enclosed;* otherwise they will be sent by express.

In ordering please state how to ship. Should this be omitted, we will use our own discretion.

THE ROCHESTER OPTICAL COMPANY
an historical introduction

The Rochester Optical Company, manufacturer of Premo Cameras, was founded in 1883, during a decade of significant change in photographic technology. The development of new emulsions, of film, and of equipment adapted to their use, ushered in a new era. Photography was transformed from an esoteric art limited to professionals and highly dedicated amateurs. By the end of the 1880's almost anyone could take a picture.

For centuries men had been fascinated with the idea of capturing and preserving the image of nature. During the Renaissance a device called the *camera obscura*—literally a dark room—was used as a diversion of the wealthy and an aid to artists and draftsmen. The principle was a simple one, familiar to every school boy who has ever made a "pinhole" camera out of a shoebox and tissue paper. Light was permitted to enter a closed box through a small hole which served as a lens. The wall opposite the lens was made of ground glass, and the inverted image that appeared on it could be viewed from outside the box.

During the eighteenth century, chemical research opened the way to a means of fixing the image projected on the ground glass through the discovery of light sensitive compounds. It was not, however, until 1839 that a practical method of fixing the camera image was made public. This invention, the results of the collaborative efforts of Joseph Nicéphore Niépce and Louis Jacques Mandé Daguerre, was an immediate success. Daguerreotype salons, concentrating on portraiture, were opened around the world.

The daguerreotype was a positive process, producing a single copy on a silver-coated copper plate sensitized by exposure to Iodine vapor. The resulting photographs were sharp and clear, with strong tonal qualities. But daguerreotypes were fragile, expensive, and could not be reproduced. The tintype, a positive photograph made on a sensitized sheet of tin or iron, was especially popular in the United States after the Civil War. It was cheaper than the daguerreotype, but not as fine a copy and, again, not reproducable.

At almost the same time that Daguerre announced the perfection of his process, William Henry Fox Talbot, an Englishman, disclosed his own method of making photographs. Talbot's technique, using sensitized papers, was a negative-positive process, and thus foreshadowed modern photographic methods. The rough papers he used, however, produced

blurred and coarse-textured prints. The public preferred the sharp clarity of the daguerreotype.

In the 1850's the development of glass plates coated with collodion overwhelmed all other methods of making photographs. Like Talbot's, this was a negative-positive process. The images, brilliant and sharp as the daguerreotype, could be reproduced many times. The first photo-journalists used these wet plates to cover the Crimean War and the American Civil War, as well as the opening of the American West. Wet plates were an improvement, but they also had disadvantages. Since they had to be prepared immediately before insertion in the camera and developed immediately afterwards, the photographer who wished to leave his studio had to carry his darkroom with him. The low sensitivity of the available printing papers also made enlarging impractical. Cameras, therefore, were large and unwieldy for the handling of glass plates ranging in size from 4 x 5 inches to 20 x 24 inches or more. No wonder that photography was the province of professionals and a small band of hardy amateurs.

By 1883 the cumbersome wet plates had almost entirely been replaced by the new dry plate process. These plates, produced by commercial firms, were prepared at the factory with a sensitized gelatine emulsion. Furthermore, they were allowed to "ripen" after preparation, so that exposure times as fast as 1/25th of a second were possible. Also new bromide printing papers, like the plates available ready to use, had been placed on the market. The intricacies of darkroom work had thus been reduced to something many amateurs could handle.

It was to these amateurs that W. F. Carlton decided to appeal when he issued the Rochester Optical Company's first catalog in 1883. The catalog was actually in the form of an instruction manual entiled "The Amateur Photographer's Instruction Book." The front of the little pamphlet gave information on exposing and developing negatives, and on printing. Only a few pages at the back of the book were devoted to equipment.

The featured camera was the "American Challenge," a camera similar to one which had been marketed previously by Wm. H. Walker & Company. Carlton took over the Walker firm in the spring of 1883, evidently acquiring the rights to the camera, but modifying its name. The Walker model was a view camera, to be used on a socket tripod so that it could be swung. It featured monorail focusing, and a three-hole orifice plate as a diaphragm. The lens cap served as the shutter.

During the 1890's the Rochester Optical Co. introduced a variety of more sophisticated view cameras. Features included reversible backs, rack and pinion focusing, iris diaphragms, pneumatic and hand-operated shutters, and improved lenses. More accessories, in the form of improved tripods and carrying cases, were added to the line, as well as a larger assortment of darkroom equipment.

Throughout the 1880's technological change in the photographic field continued to be rapid. In 1884 the first flexible film, patented by George Eastman, was placed on the market. The film was inserted in the camera on a roller holder, for which the patent was held by Eastman and William H. Walker, now his associate. Eastman's new film had one disadvantage. It was not transparent; the gelatin film was mounted on a strip of paper which had to be removed in the darkroom. To counteract this problem, Eastman introduced a new camera in 1888. Called the Kodak, it featured a roll holder as part of the box camera. When the 100-exposure roll with which it was furnished had been used, the whole camera was returned to the dealer or the factory. There the exposed film was developed and the camera was reloaded with a new roll. Eastman marketed the camera with the slogan, "YOU PRESS THE BUTTON, WE DO THE REST."

Eastman's innovations, and his inspired marketing techniques opened photography to the general mass of people. Anyone could take a picture, not just to record events or scenes or persons of great importance, but to reproduce his own activities and those of his family on film. During the 1880's several companies besides Eastman introduced an enormous variety of hand cameras. There were any number of box cameras, known

A turn-of-the-century men's camera club posed in the midst of nature. The bowler and chesterfield were not official photographic garb.—*George Eastman House Collection*

then as "detective" cameras. There were also miniatures, disguised as watches, cane handles, and stickpins in specially arranged cravats.

Rochester Optical was cautious about appealing to the new mass market. In 1886 their catalog offered Eastman roll film and holders, negative paper (cut film), and printing paper. Nevertheless, they offered the film almost reluctantly, and the printed matter in that and succeeding catalogs stressed their own preference for glass plates. In 1889, the year that Eastman first marketed transparent film, Rochester Optical finally succumbed to the demand for more compact cameras. They introduced the "Midget Pocket Camera." One-and-a-half inches thick when folded, it weighed less than a pound and sold for $25.

Rochester Optical advertised the "Midget" as "invaluable for ladies, tourists, bicyclists and canoeists." In doing so, it echoed most of the photographic literature addressed to amateurs at the turn of the century. Photography was viewed as an extension of the appreciation of natural beauty; the same awe of scenic wonders formed a persistent theme in Victorian art and literature. As urbanization increased in America, the yearning for communion with nature grew even stronger. The bicycle made it possible for almost any man, even one who could not afford a horse or carriage, to get out into the countryside. He could not only enjoy the soothing effects of his jaunt; he could memorialize it with the hand camera, strapped, in its convenient carrying case, to the handlebars.

The "Midget," originally a small view camera, was followed the next year by a detective version, and two other hand cameras. Although Rochester Optical continued to feature their view cameras, they were obviously paying more attention to the compact hand cameras. In 1893, along with new view cameras, they introduced "The Premo," to ". . . include the latest improvements in Hand Cameras, and also possess the advantageous features of the regular View Camera; yet, withal, to preserve compactness."

For the next two years the view cameras gradually decreased in importance, although the last and most elegant of Rochester Optical's view cameras, "The Carlton," was introduced in 1895. In the same year, seven additions were made to the Premo line. In 1896, for the first time, the catalog appeared under the title, "The Premo Camera."

The 1898 catalog is the most elaborate the company ever issued. The description of almost every camera is prefaced or followed by a photograph taken with that model. The graphic art is also lavish. Although Rochester Optical products were also handled by outside distributors, this catalog, like their others, clearly was aimed at their extensive direct mail market. The company was imitating the marketing practices of other American manufacturers who possessed technologically new products destined for a large audience, a market reaching from coast to coast.

Although the front matter in the 1898 catalog states that 25 differ-

ent styles are shown, there are actually only 22 described in detail. Six of these were available with a choice of lenses, and the majority could be obtained in a range of sizes. The cameras shown are a testimony to the immediate success of the Premo line and its tremendous growth in a period of five years.

After the introduction of the first Premo in 1893, three more cameras, the "Premo B," "C," and "D," were added in 1894. These were modified for adaptation to roller holders in 1895, and four more of the cameras shown were added to the line: the "Premo Sr.," the "Long Focus Premo," and the inexpensive "Premo V." A stereoscopic Premo had also been offered in 1895, but the three stereo versions in the 1898 catalog were all introduced in 1896. Another two of the cameras shown also date back to 1896: the "Premo Sr. Special," and the original "Pony Premo." Three of the cameras had been introduced in 1897: the "Reversible Back Premo," the "Pony Premo A," and the "Pony Premo Sr." The remainder were new for 1898, with special emphasis on additions to the Pony line.

The Premo camera seems to have enabled the Rochester Optical Co. to enlarge its base of operations. It was undoubtedly thanks to immediate public acceptance of the new camera that the company weathered the severe financial panic in 1893. In fact, Rochester Optical increased its plant capacity that year.

Just where the company was located when it started in business is not certain. The return address in advertisements of 1883 and 1884 is given simply as Box C, Rochester, N.Y. In 1887 its address was 11 & 13 Aqueduct Street, and in 1891 it was at 5 South Water Street. In 1893, the Premo's first year, it had expanded to fill 5 to 11 South Water Street. By 1895 it occupied its own building, which might well be called the house that Premo built, still standing at 39 to 49 South Street.

While the company never issued another catalog as elaborate as that of 1898, the business evidently continued to be successful for the next two years. Conditions in the photographic industry in the last two decades of the nineteenth century were as chaotic as in the automotive industry immediately before and after World War I, or the computer industry in the 1960's. Dozens of new companies proliferated to join those which had been established in the daguerreotype era, each offering some small technical innovation. By the end of the century, the inevitable shake-out was well under way.

It affected such major firms as E. and H. T. Anthony, and Adams and Scovill, both of which had histories dating back to the 1840's. In 1901 they merged, forming a company known as Anthony and Scovill which in 1907 adopted the name Ansco. In November, 1899, the Rochester Optical and Camera Company was formed, incorporating not only Rochester Optical, but three of its hometown competitors, and two other companies. The

five were: The Rochester Camera & Supply Company (Poco); The Ray Camera Company, of Rochester (Ray Camera); The Monroe Camera Company, of Rochester (Monroe); The Western Camera Manufacturing Company, of Chicago (Cyclone); and the plate hand camera business of E. and H. T. Anthony and Company. The two surviving lines were Poco and Premo, the latter having been registered as an official trademark the previous month.

The merger was not a success. Although the new company showed a profit of over $100,000 for its first year of operation, its losses were over $100,000 annually for the next two years. In 1903 its entire capital stock was acquired by Eastman Kodak, already the undisputed giant of the American photographic industry, for payment of approximately $90,000 in cash and assumption of over a quarter of a million dollars worth of liabilities.

Eastman reorganized the company under the old name of the Rochester Optical Company, and operated it as a wholly-owned subsidiary until 1907. In that year, the company was merged into Eastman Kodak, and became known as the Rochester Optical Division, Eastman Kodak Company. Premos must have established sufficient reputation to have acquired a faith-

Eastman Kodak Patent Department Museum
Rochester Optical Company

ful following. Eastman Kodak continued to produce cameras under the Premo name until 1922. At that time the name Rochester Optical Division was dropped from Eastman literature. The division was sold, along with several other Eastman Kodak subsidiaries, to the Folmer Graflex Corporation in 1926.

The type of camera produced under the Premo name was probably doomed to obsolescence by the 1920's. Just as the more compact hand cameras had displaced the bulky view cameras at the end of the century, the hand cameras were to be replaced by lighter, miniaturized instruments. In 1924 the first Leica was introduced; in 1927 the Rolleiflex; and in 1932 the Contax. Next to them, the Premo cameras look like behemoths.

Nevertheless, for their day, Premos were fine cameras. Although the 1898 catalog claims that "Manufacturers recognize the value of photography as a means of accurately representing their products," the photographs fail to do justice to the actual instruments. Premos were fine crafted. Existing examples in good condition still glow with highly-polished mahogany, meticulously-machined brass and nickel-plated fittings, black leather, and ivory. By modern standards, they cannot qualify, mechanically or optically, as precision instruments. But at the turn-of-the-century they offered a well-made machine, capable of taking excellent photographs, to amateurs interested in quality.

Suggestions for further reading

Very little has been written about American photographic equipment of the late nineteenth century. The most valuable source material presently available is that contained in the catalogs of manufacturers and dealers, and in the contemporary photographic journals, some of which are included in this listing.

Information on Premo cameras and the Rochester Optical Company was obtained from catalogs and papers in the collection of the Eastman Kodak Patent Department Museum, Rochester, N.Y.

general:

EDER, J. M. *History of Photography.* New York, 1945. Non-illustrated translation of *Geschichte der Photographie.* Halle, 1932.

NEWHALL, BEAUMONT. *The History of Photography.* New York: The Museum of Modern Art, 1964.
A basic book in the field, with strong emphasis on photography as an art form.

SIPLEY, LOUIS WALTON. *Photography's Great Inventors.* Philadelphia: American Museum of Photography, 1965.

TAFT, ROBERT. *Photography and the American Scene.* New York: Dover, 1964. Reprint of 1938 Macmillan edition.
Still probably the best single volume on American photography from the point of view of social history and technical change.

for the collector:

GROSS, HARRY I. *Antique and Classic Cameras.* Philadelphia: Chilton, 1965.
Some useful photographs.

SIPLEY, LOUIS WALTON. *A Collector's Guide to American Photography*. Philadelphia:
 American Museum of Photography, 1957.
Primarily on earlier material.

WILSON, EDWARD L. *Cyclopedic Photography*. Philadelphia: Wilson, 1894.
Combination dictionary and encyclopedia of the period.

late nineteenth-century periodicals:

American Amateur Photographer
Anthony's Photographic Bulletin
Wilson's Photographic Magazine

current periodicals:

Graphic Antiquarian
Mr. Donald P. Blake, Editor and Publisher
 3851 Esquire Place
 Indianapolis, Ind. 46226
The Photographic Collector's Newsletter
Mr. Eaton S. Lothrop, Jr., Editor and Publisher
 1545 East 13th Street
 Brooklyn, N.Y. 11230

Collections of late nineteenth-century cameras and equipment

The following public and private museums have indicated that they do have within their
holdings more than a few cameras and other photographic equipment produced by
Rochester Optical Company and/or other manufacturers, or possess important research
material on photography of this period.

Chicago Historical Society, Chicago, Ill.
Eastman Kodak Patent Department Museum, Rochester, N.Y.
Florida State Museum, Gainesville, Fla.
George Eastman House, Rochester, N.Y.
Henry Ford Museum & Greenfield Village, Dearborn, Mich.
Michigan Historical Commission Museum, Lansing, Mich.
Missouri Historical Society, St. Louis, Mo.
Museum of History and Industry, Seattle, Wash.
Museum of Modern Art, New York, N.Y.
New Jersey Historical Society, Newark, N.J.
New York Historical Society, New York, N.Y.
Ohio Historical Society, Columbus, Ohio
Riverside Museum, Riverside, Calif. (home of the Camera Collector's Club)
Smithsonian Institution, Museum of History and Technology, Washington, D.C.
State Capitol Historical Museum, Olympia, Wash.
State Historical Society of Wisconsin, Madison, Wis.
William Penn Memorial Museum, Harrisburg, Penn.
Witte Memorial Museum, San Antonio, Texas